# Sarnia Ontario Book 1 in Colour Photos, Saving Our History One Photo at a Time

Photography
by Barbara Raué
2015

Series Name:
Cruising Ontario

Book 133: Sarnia Book 1

Cover photo: 127 Christina Street South, Page 45

# Series Name: Cruising Ontario
# Saving Our History One Photo at a Time
# in colour photos

Books Available in Alphabetical Order:
Aberfoyle, Acton, Alton, Amherstburg, Ancaster, Arthur, Aylmer, Ayr, Bloomingdale, Brantford, Burlington, Caledon, Caledonia, Cambridge, Clifford, Conestogo, Delhi, Dorchester to Aylmer, Drayton, Drumbo, Dundas, Eden Mills, Elmira, Elora, Essex, Fergus, Guelph, Hagersville, Hamilton, Hanover, Harriston, Hespeler, Jarvis, Kingsville, Kitchener, Linwood, Listowel, London, Lucknow, Mitchell, Mono, Mount Forest, Neustadt, New Hamburg, Niagara-on-the-Lake, Oakville, Orangeville, Orillia, Owen Sound, Palmerston, Peterborough, Port Elgin, Preston, Rockwood, Seaforth, Sheffield, Shelburne, Simcoe, Southampton, St. Jacobs, St. Thomas, Stoney Creek, Stratford, Tillsonburg, Waterdown, Waterrford, Waterloo, Wellesley, Windsor, Wingham, Woodstock

Book 113: Waterford
Book 114-116: Waterloo
Book 117-119: Windsor
Book 120-121: Amherstburg
Book 122: Essex
Book 123-124: Kingsville
Book 125-127: Woodstock
Book 128: Thamesford
Book 129-132: St. Mary's
Book 133-136: Sarnia

# Other Books by Barbara Raue

Coins of Gold

Arrows, Indians and Love

The Life and Times of Barbara
Volume 1: Inventions That Have Enhanced My Life
Volume 2: Entertainment That I Have Enjoyed
Volume 3: East Coast Trips
Volume 4: Olympics Have Always Intrigued Me
Volume 5: Wonders of the World
Volume 6: Caribbean Cruises We Have Enjoyed
Volume 7: Animals
Volume 8: Storms and Other Major Disasters in My Lifetime
Volume 9: Wars, Terrorist Attacks and Major Disasters

The Cromwell Family Book

Laura Secord Discovered

Daddy Where Are You?

Visit Barbara's website to view all of her books
http://barbararaue.ca

Sarnia is a city in Southwestern Ontario located on the eastern bank of the junction between the Upper and Lower Great Lakes where Lake Huron flows into the St. Clair River, which forms the Canada-United States border, directly across from Port Huron, Michigan.. It is the largest city on Lake Huron. The city's natural harbor first attracted the French explorer LaSalle, who named the site "The Rapids" when he had horses and men pull his forty-five-ton barque "Le Griffon" up the almost four-knot current of the St. Clair River in August 1679. This was the first time anything other than a canoe or other oar-powered vessel had sailed into Lake Huron.

Captain Richard Emeric Vidal (1784-1854), one of the founders of Sarnia nurtured the little settlement for twenty years from his first visit in 1834. His wife, Charlotte Penrose Mitton (1790-1873) lived her last forty years in Sarnia and three streets bear her name (Charlotte, Penrose, and Mitton Streets).

Paul Blundy was born in Sarnia in 1918. He served in the Royal Canadian Navy in World War II. Following the war, he co-founded the McKenzie & Blundy Funeral Home. Paul served four years as a member of the Hydro-electric Commission, twenty years as a member of Sarnia City Council, eight of them as mayor. During his time on City Council, he was a strong advocate for the redevelopment of the waterfront. From 1977 to 1981, he served as M.P.P. for Sarnia. He died in 1992.

## Table of Contents

| | |
|---|---|
| Alfred Street | Page 6 |
| Brock Street North | Page 10 |
| Brock Street South | Page 24 |
| Canatara Park | Page 28 |
| Charlotte Street | Page 28 |
| Christina Street North | Page 30 |
| Christina Street South | Page 44 |
| | |
| Architectural Terms | Page 54 |
| Building Styles | Page 58 |

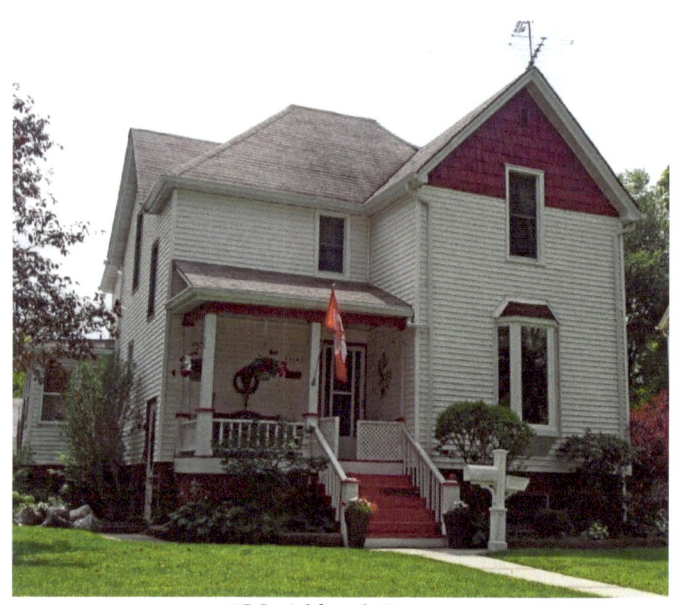

139 Alfred Street

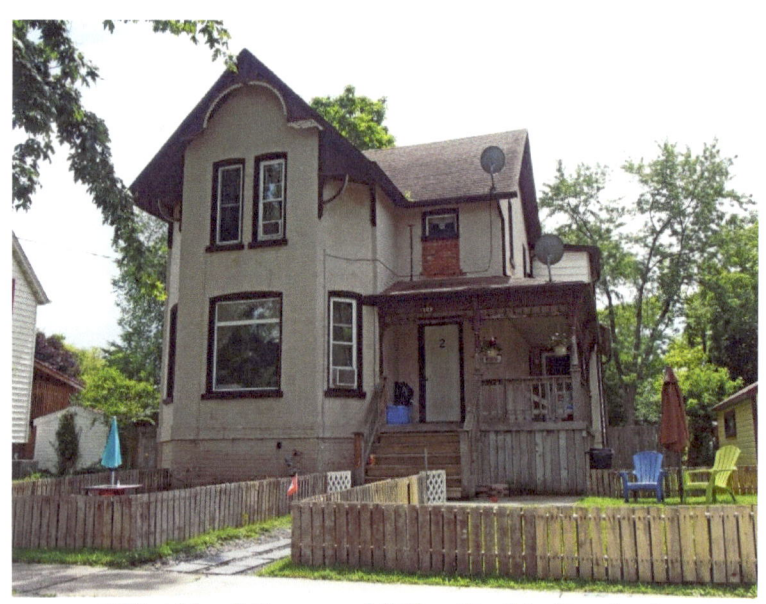

129 Alfred Street – 1892 – Gothic Revival, verge board trim on gable

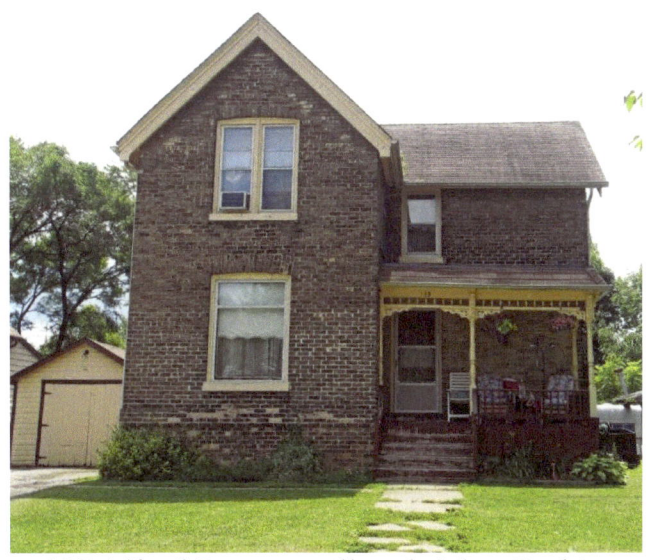

125 Alfred Street – yellow brick – Gothic, bric-a-brac on verandah

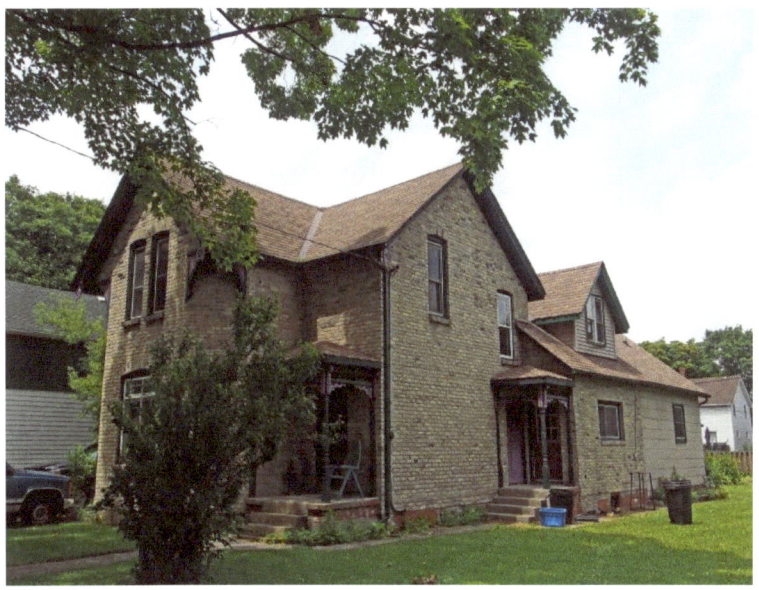

Alfred Street – Gothic Revival

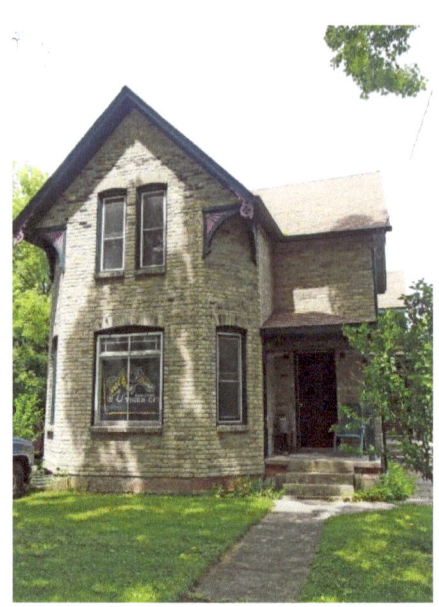

Alfred Street - Gothic

115 Alfred Street - Gothic

119 Alfred Street - Gothic

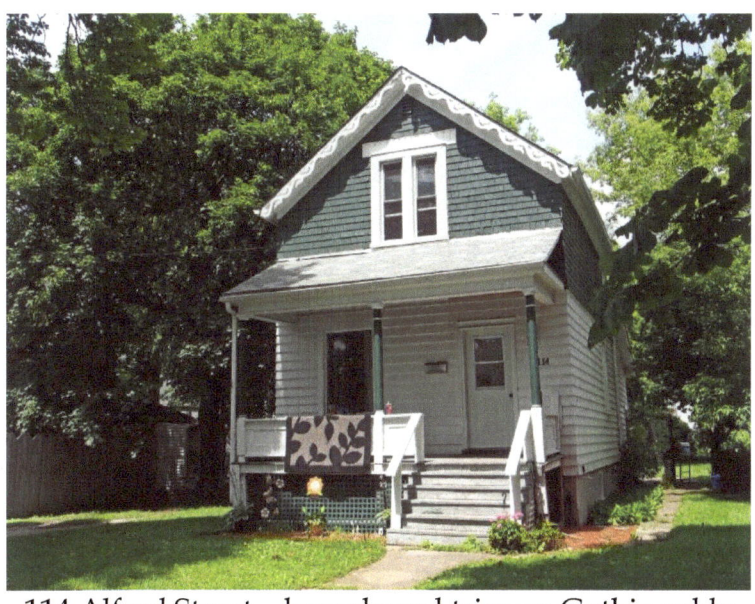

114 Alfred Street – bargeboard trim on Gothic gable

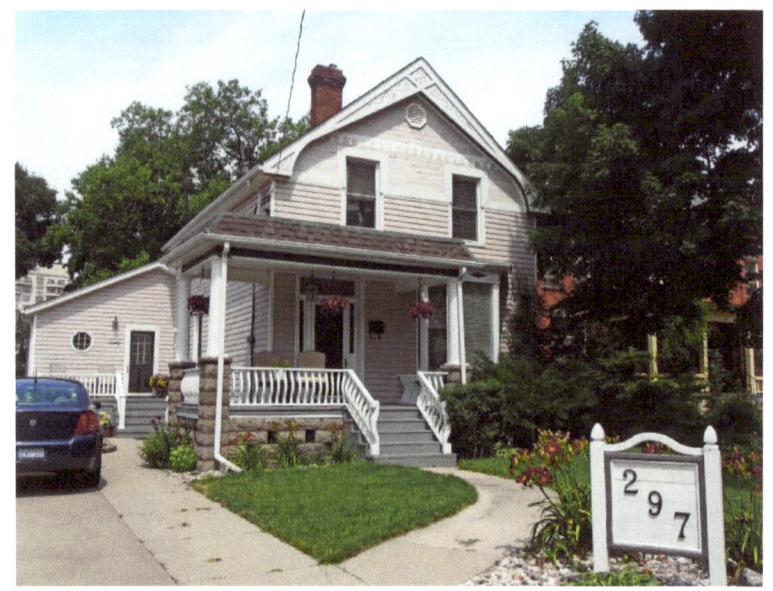
297 Brock Street North - bargeboard trim, fish scale pattern

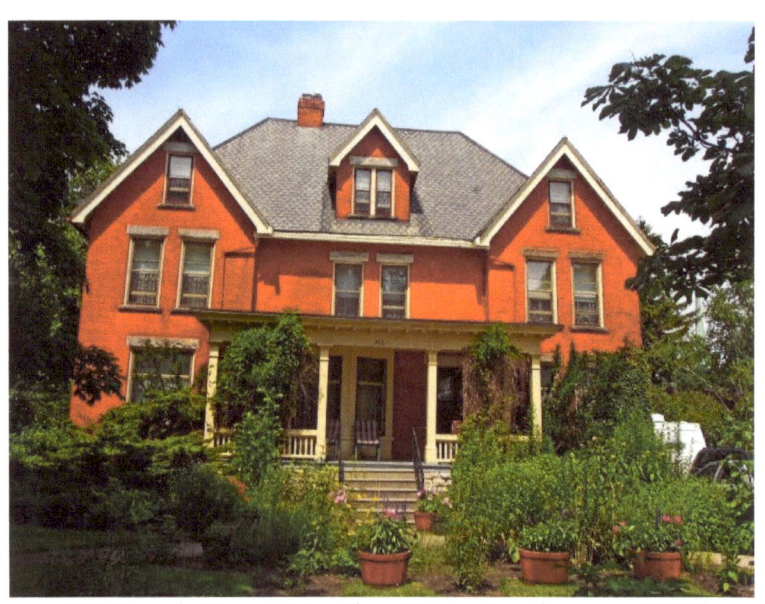
303 Brock Street North – Victorian home - 1895

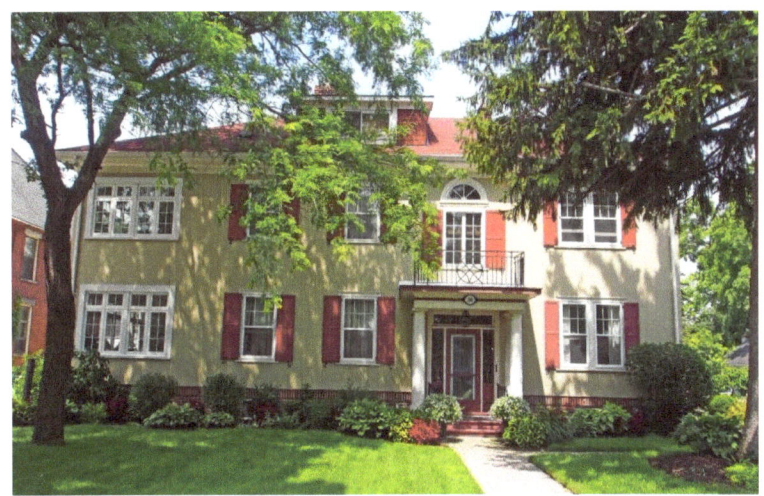

309 Brock Street North – Italianate – dormer in hipped roof, Doric pillars supporting roof for second floor balcony, sidelights and transom windows around door

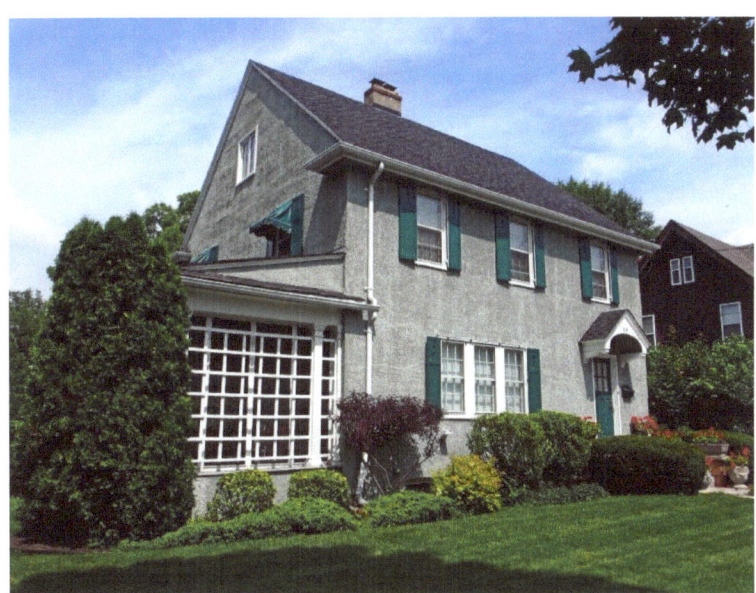

315 Brock Street North – Gothic, cornice return on gable

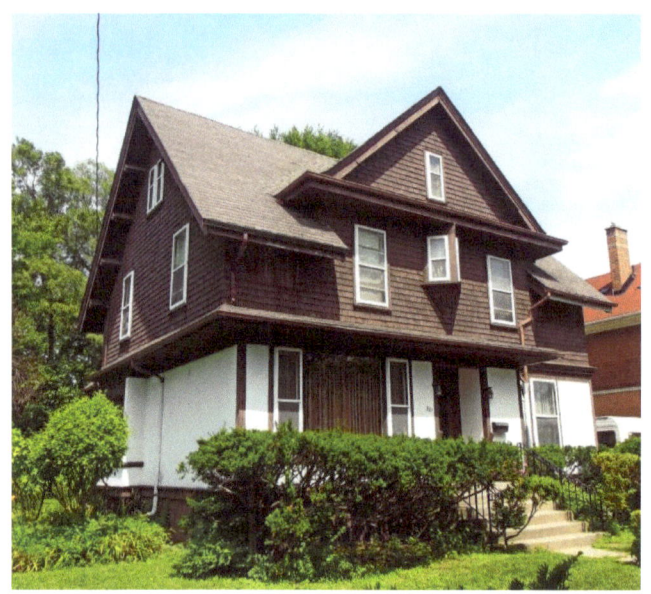

321 Brock Street North – 1905 - vernacular

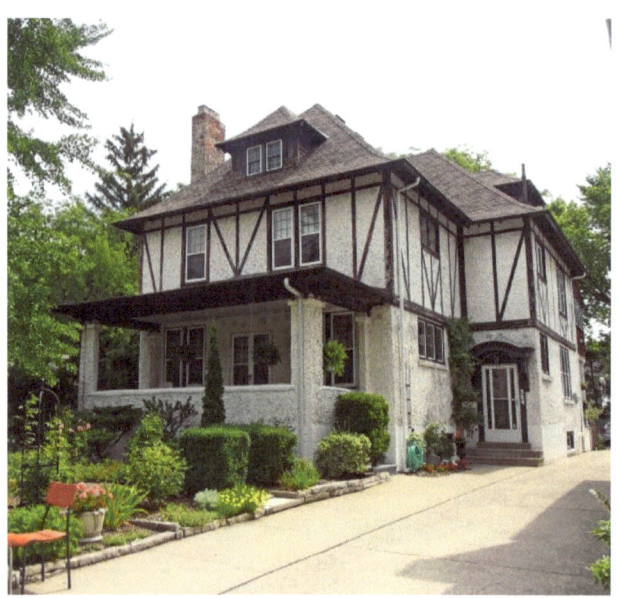

324 Brock Street North – 1917 - Tudor

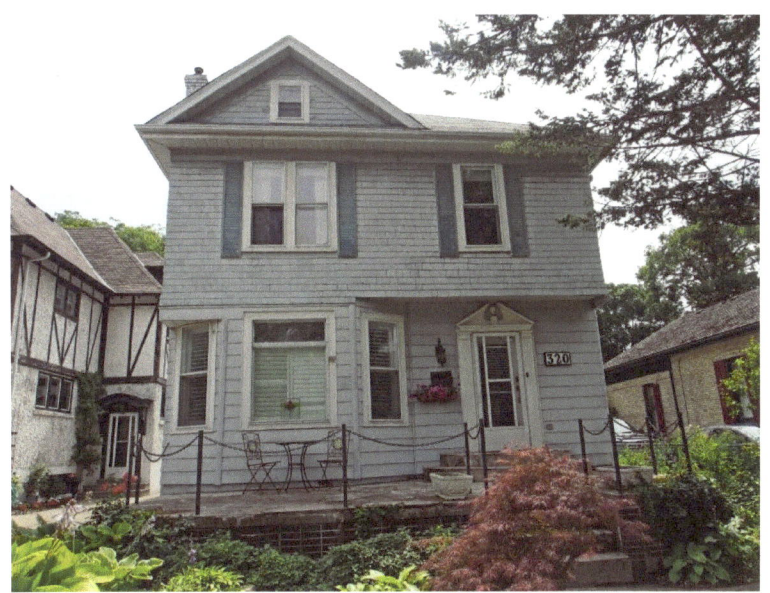

320 Brock Street North

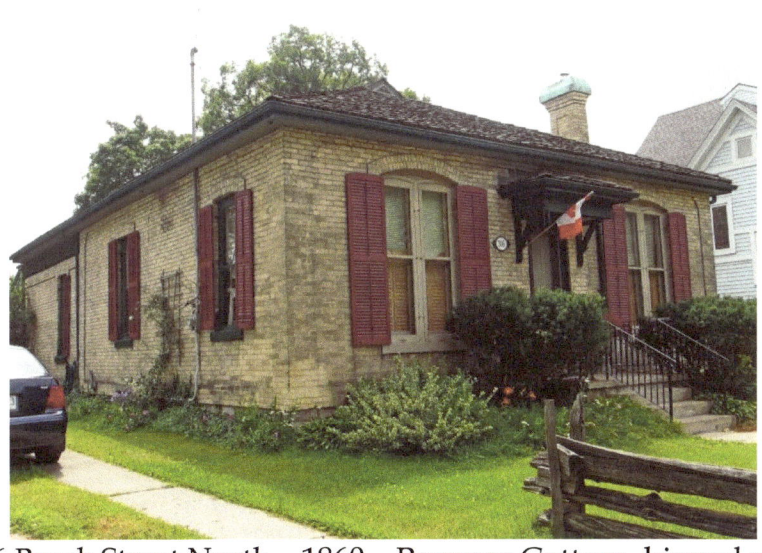

316 Brock Street North – 1860 – Regency Cottage, hipped roof

Brock Street North

304 Brock Street North

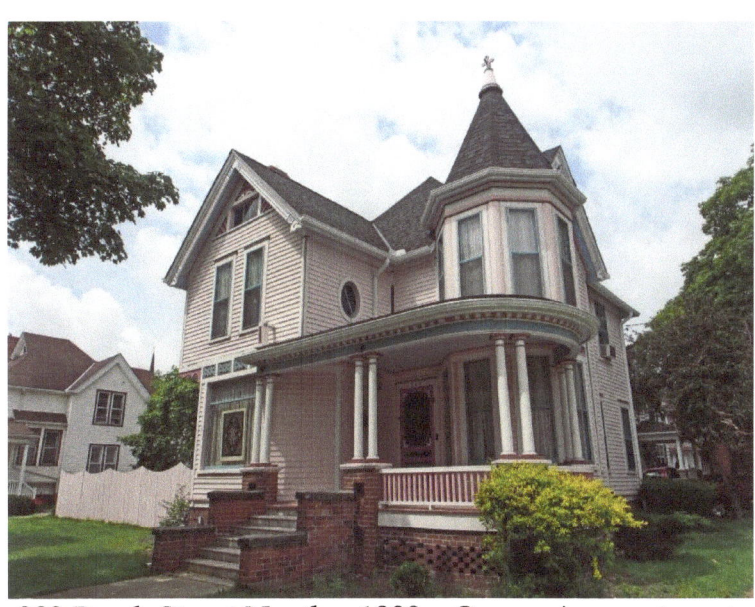

283 Brock Street North – 1900 – Queen Anne – turret, curved verandah

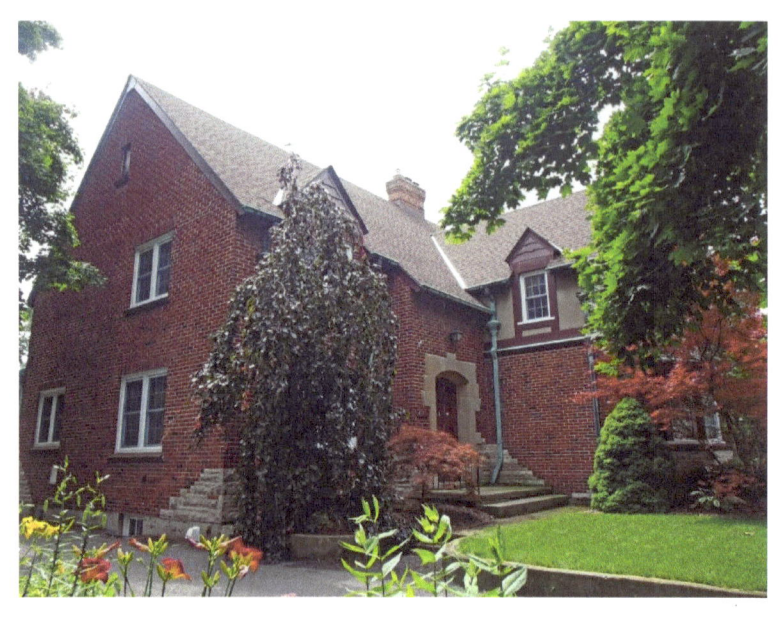

296 Brock Street North – 1951 - Tudor

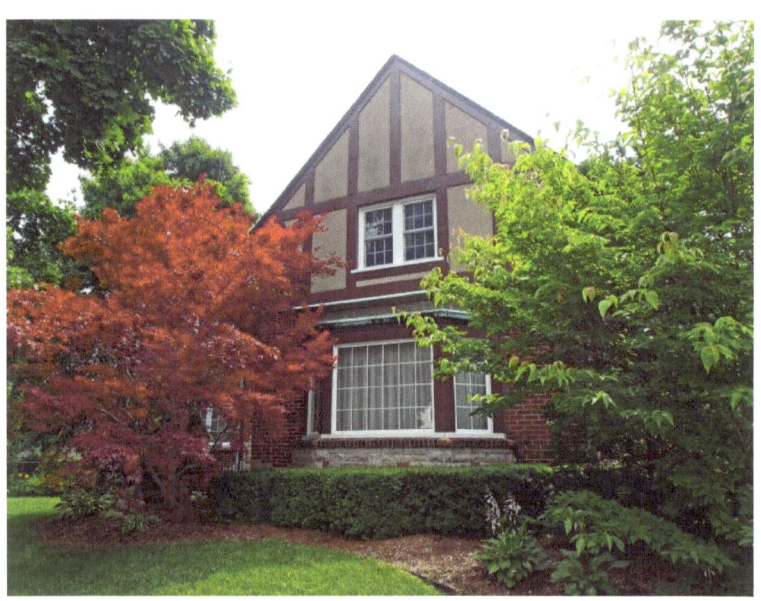

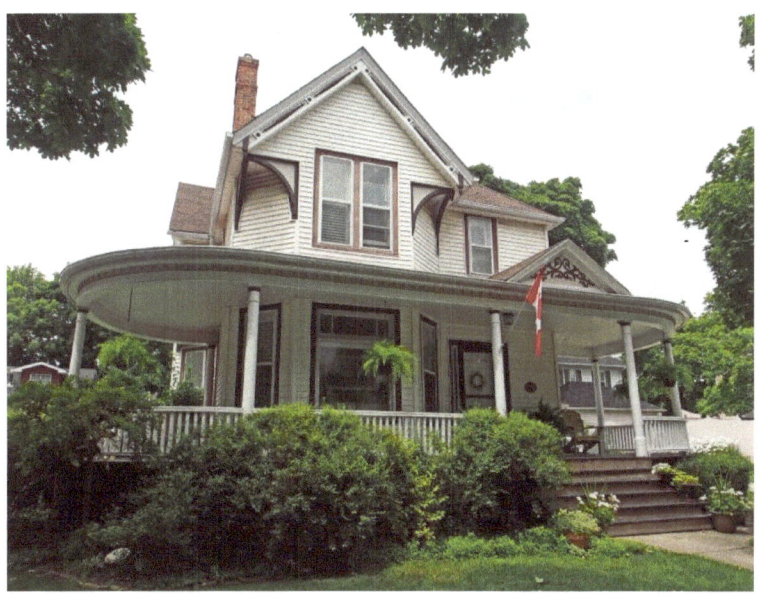

275 Brock Street North – 1900 – wraparound verandah, pediment with decorated tympanum, fretwork

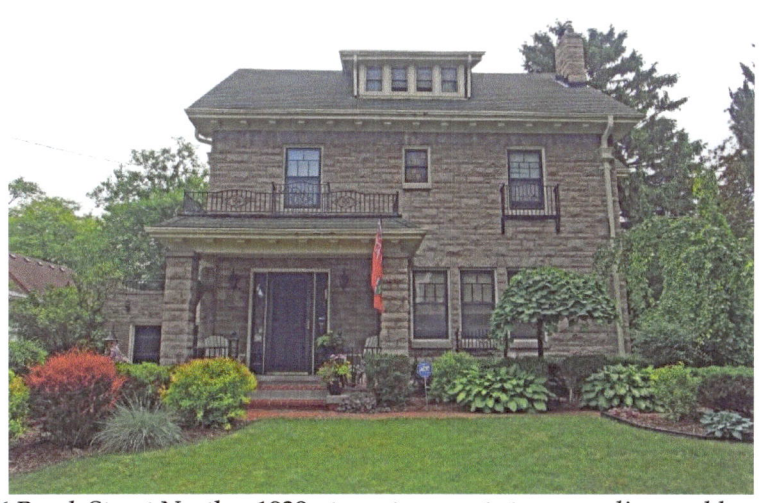

276 Brock Street North – 1929 - two storey cut stone, medium gable roof with large shed dormer window, open porch supported by cut stone piers, truncated roof of porch is decorated with a cast iron railing, small cast iron railings decorate the windows on the front wall of the house, six panelled front door flanked by decorative sidelights

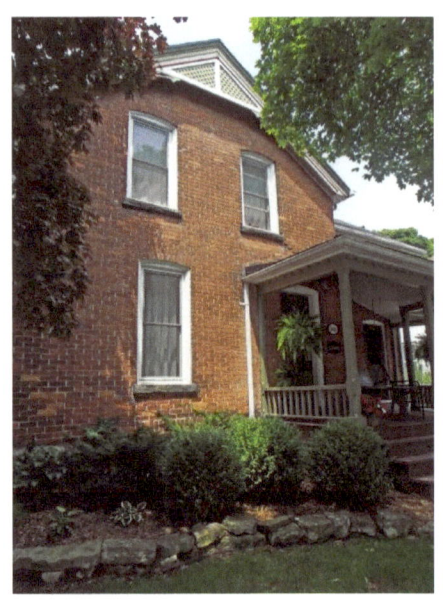

269 Brock Street North - 1880

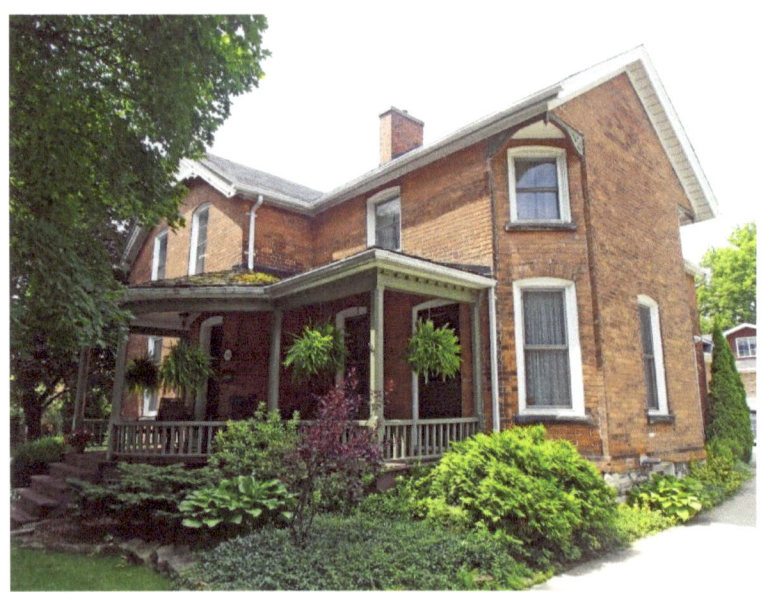

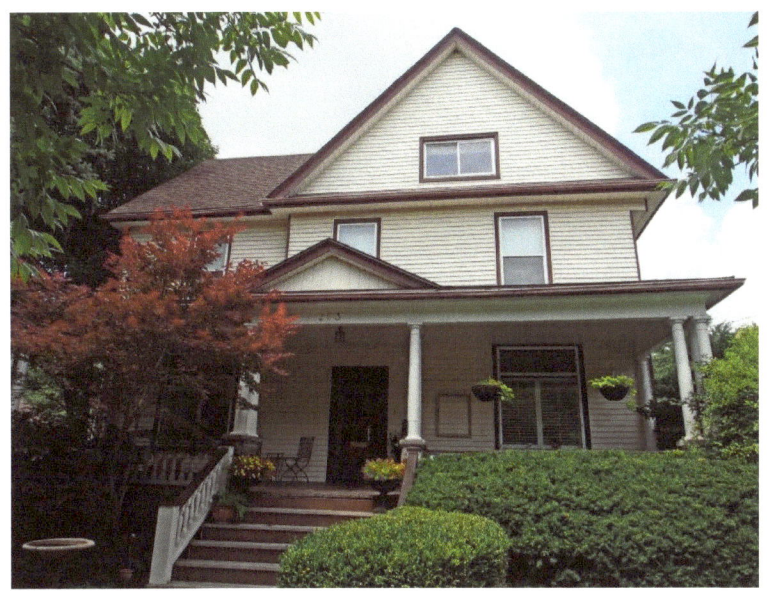

263 Brock Street North - 1908

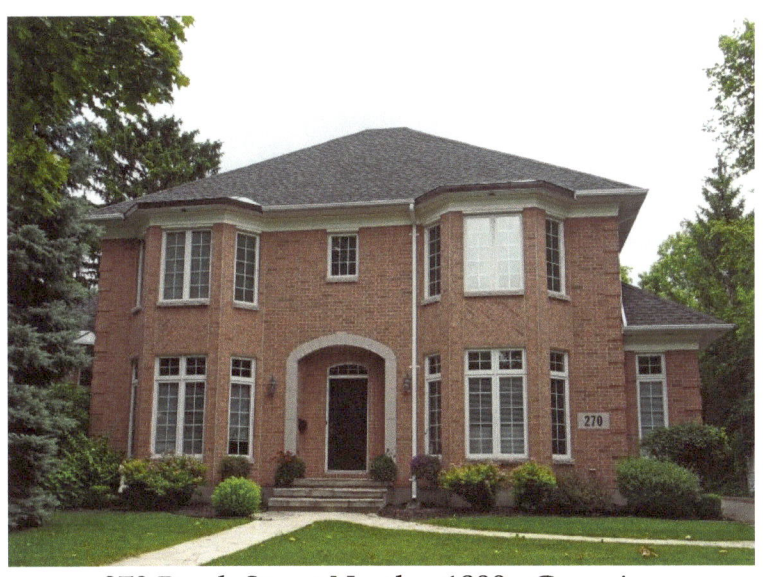

270 Brock Street North – 1890 - Georgian

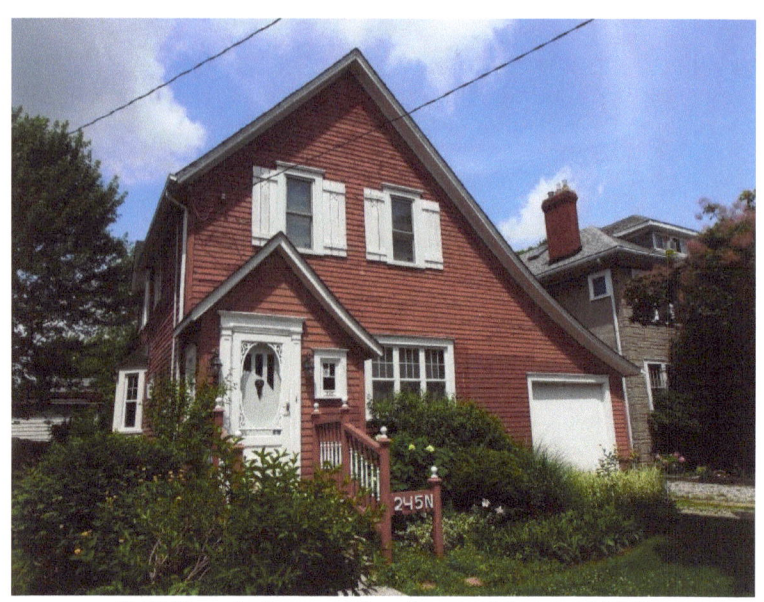

245 Brock Street North – saltbox - 1930

242 Brock Street North - Gothic

237 Brock Street North

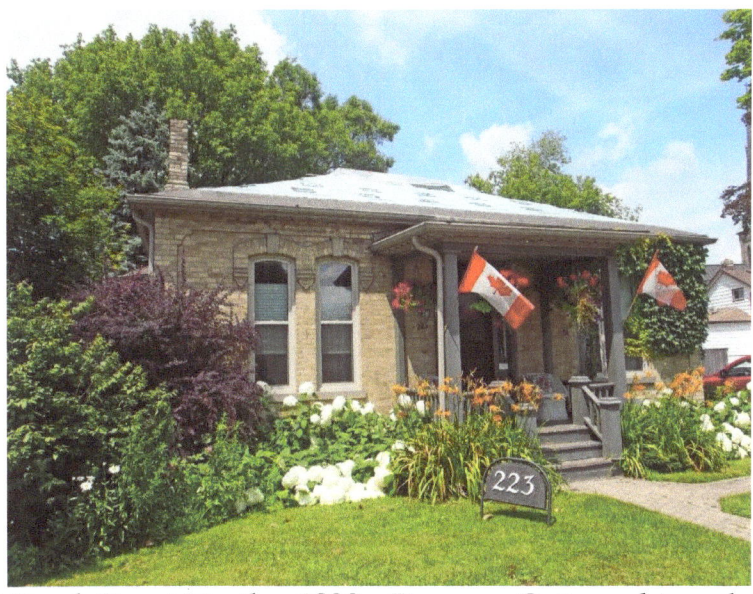

223 Brock Street North – 1890 – Regency Cottage, hipped roof

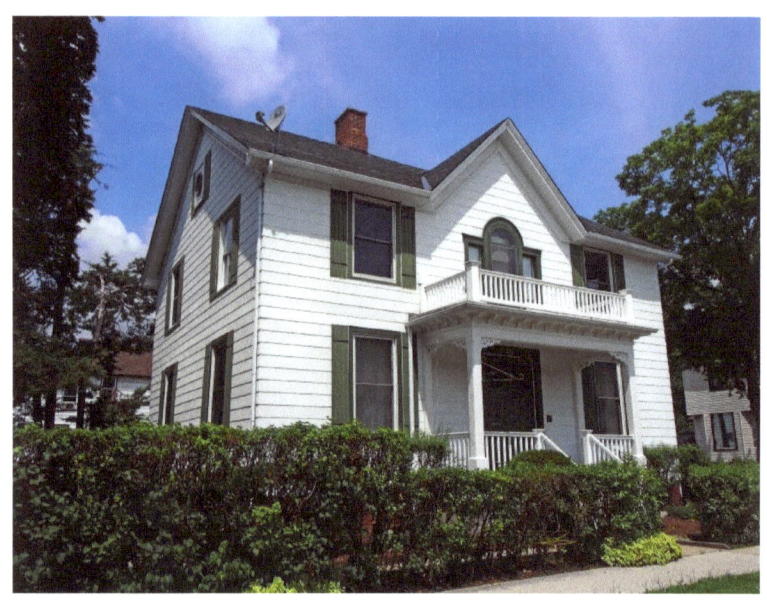

233 Brock Street North – 1890 – Gothic, second floor balcony, Palladian window

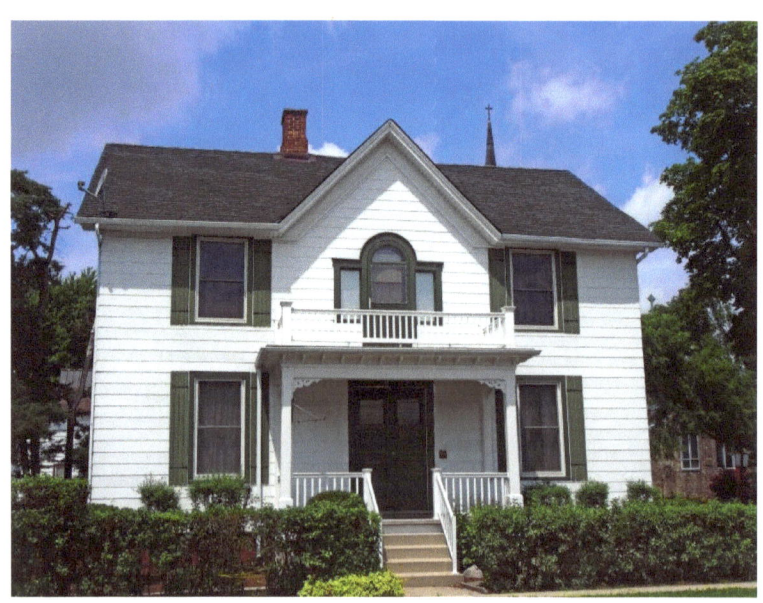

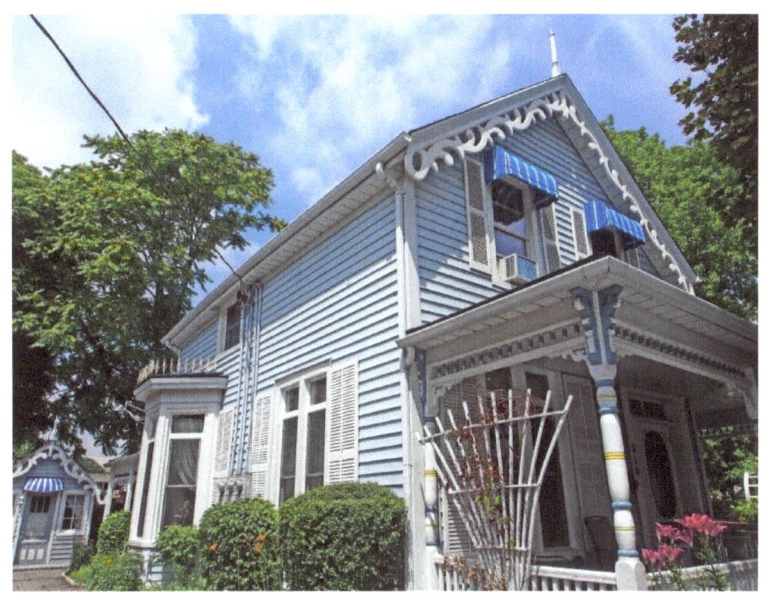

219 Brock Street North – 1895 – Gothic Revival – verge board trim on gable and finial

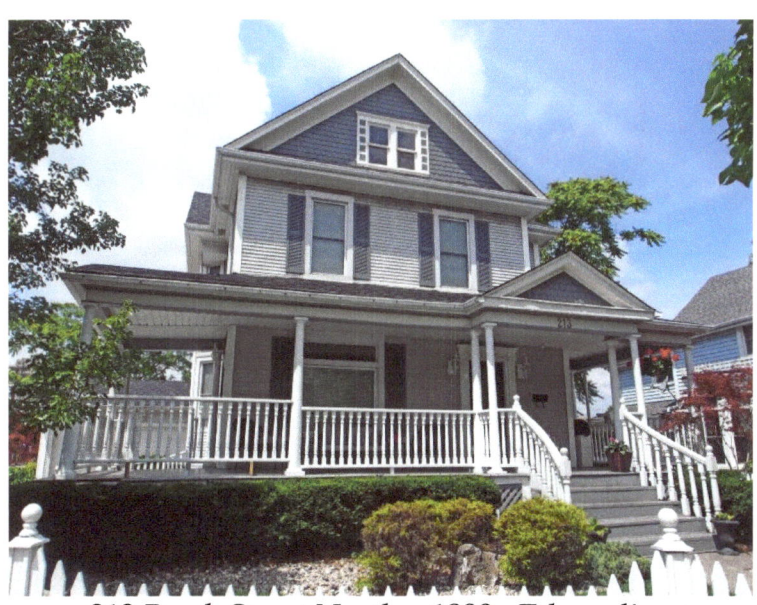

213 Brock Street North – 1890 - Edwardian

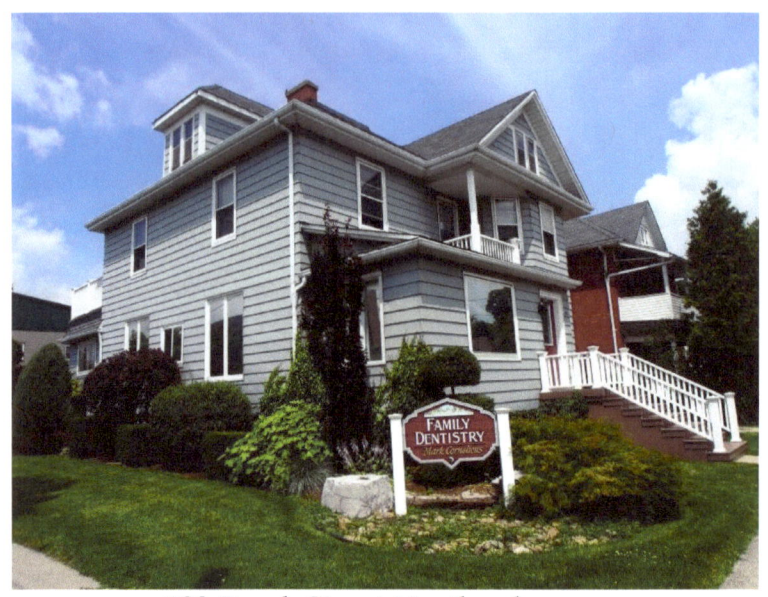
183 Brock Street North - dormer

233 Brock Street South – 1910 – Gothic Revival – bay window

208 Brock Street South

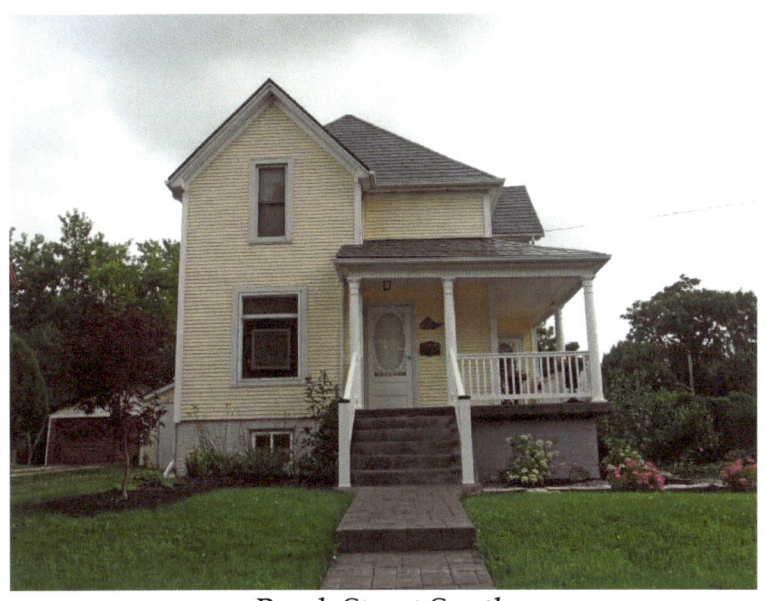
Brock Street South

166 Brock Street South

191 Brock Street South – Gothic Revival - 1890

155 Brock Street South

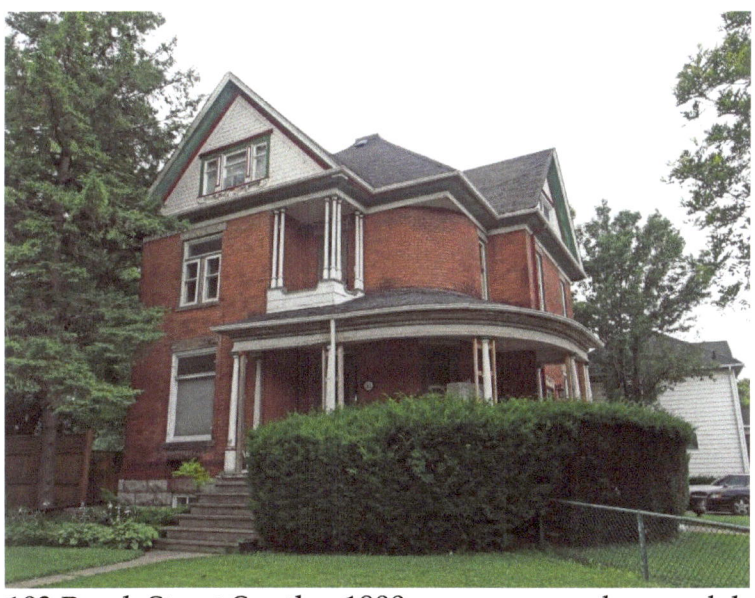

103 Brock Street South – 1900 – wraparound verandah

Canatara Park

112 Charlotte Street - full-width two-storey verandah supported by pillars

108 Charlotte Street - pediments

Mural

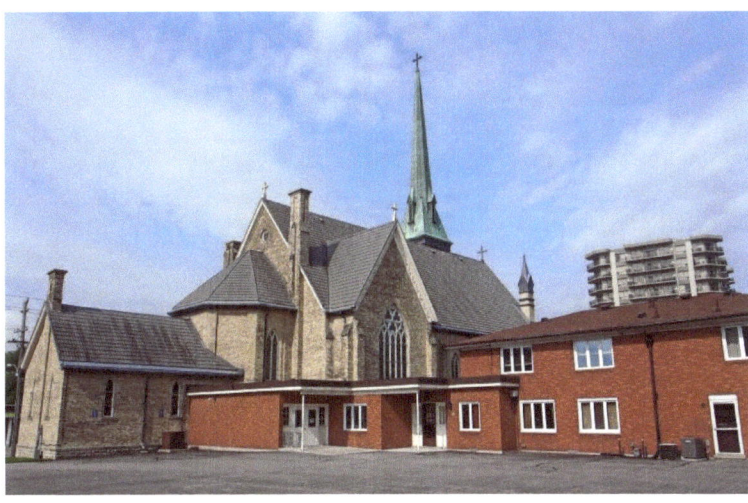

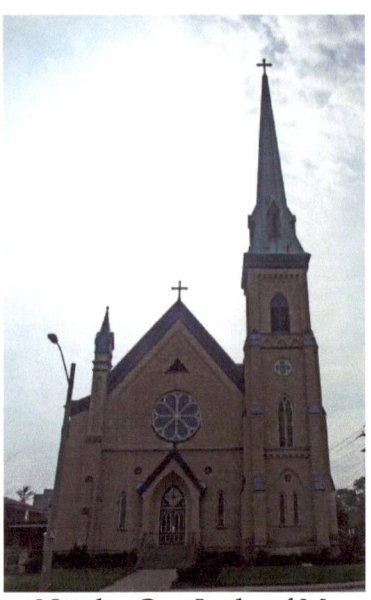

380 Christina Street North - Our Lady of Mercy Roman Catholic Church – limestone foundation, cruciform plan with an apse and a narthex, brick tower with a tall slender copper steeple with four Gothic-shaped vents rises to the cross; angled buttresses

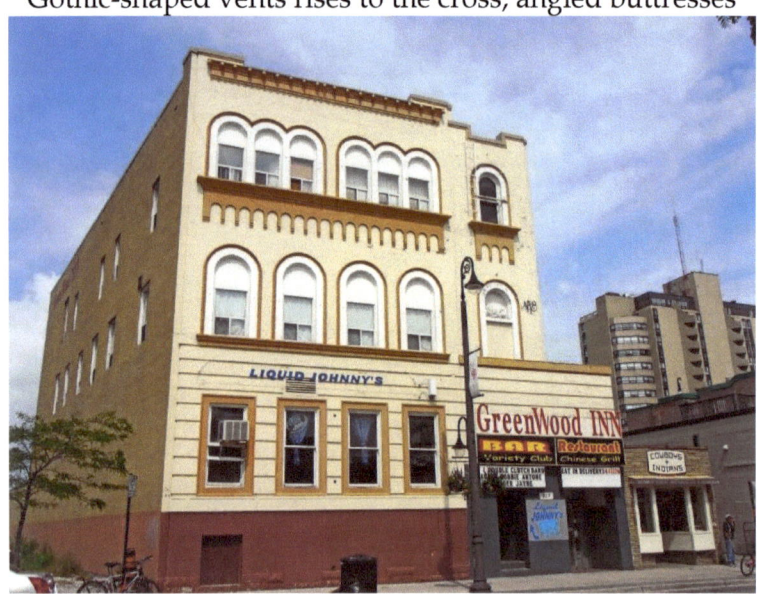

117 Christina Street North – Colborne Hotel - 1918

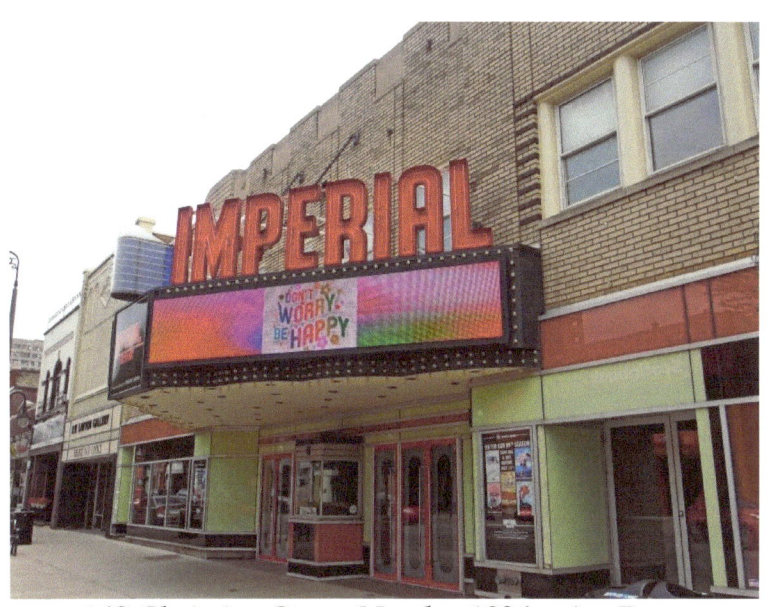

168 Christina Street North - 1936 – Art Deco – Imperial Theatre

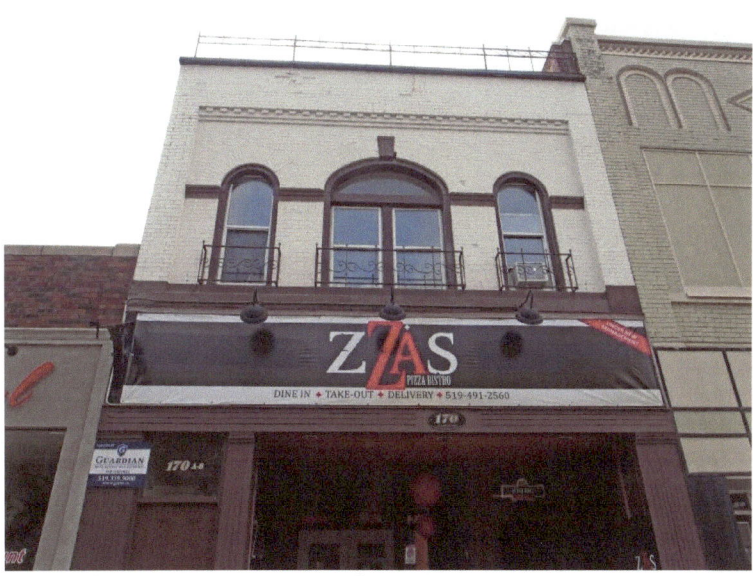

170 Christina Street North – 1900 – Zzas Pizza Eatery – dentil moulding

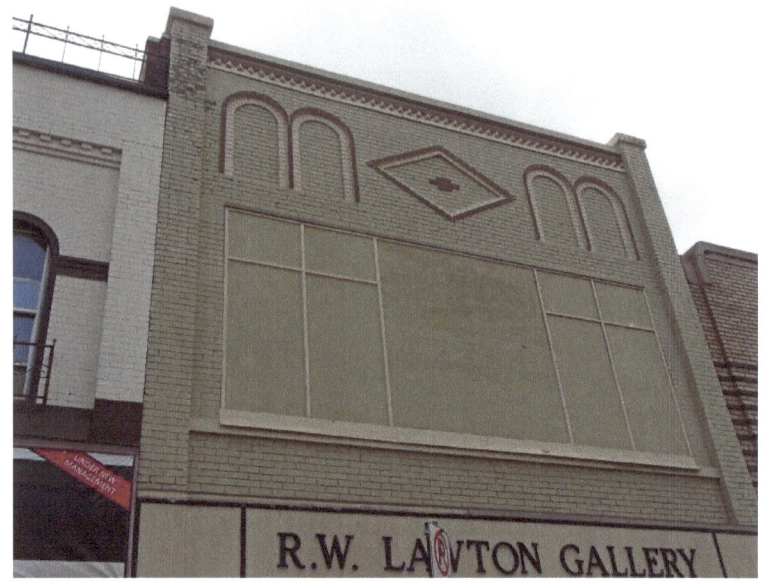

168 Christina Street North – R. W. Lawton Art Gallery
sawtooth moulding

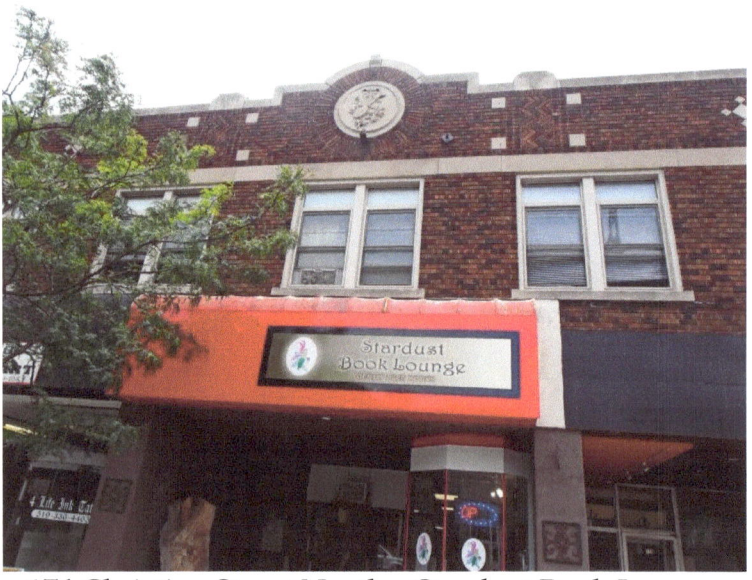

176 Christina Street North – Stardust Book Lounge

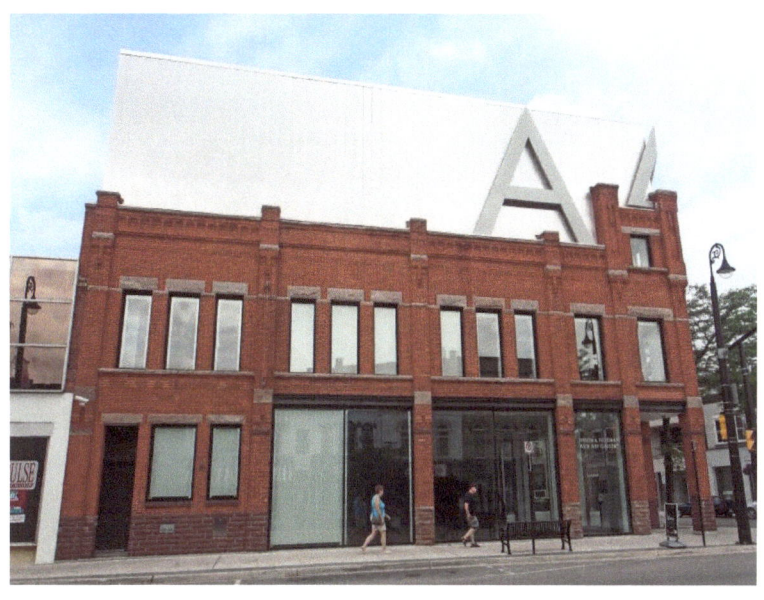

156 Christina Street North – Judith and Norman Alix Art Gallery in renovated heritage building – pilasters, dentil and saw tooth moulding

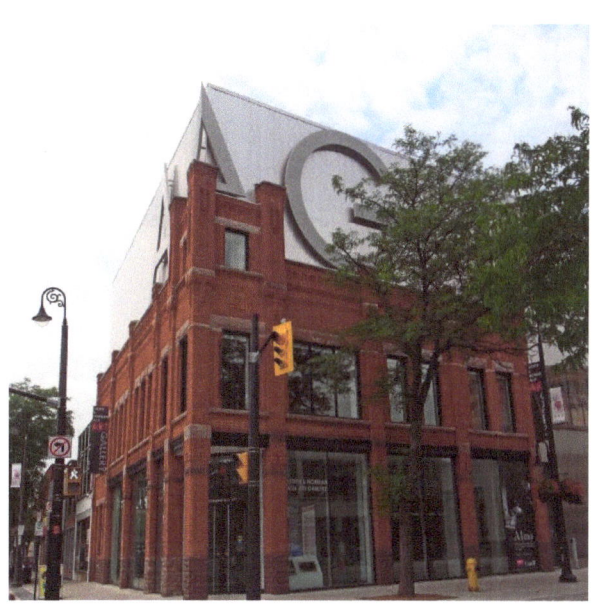

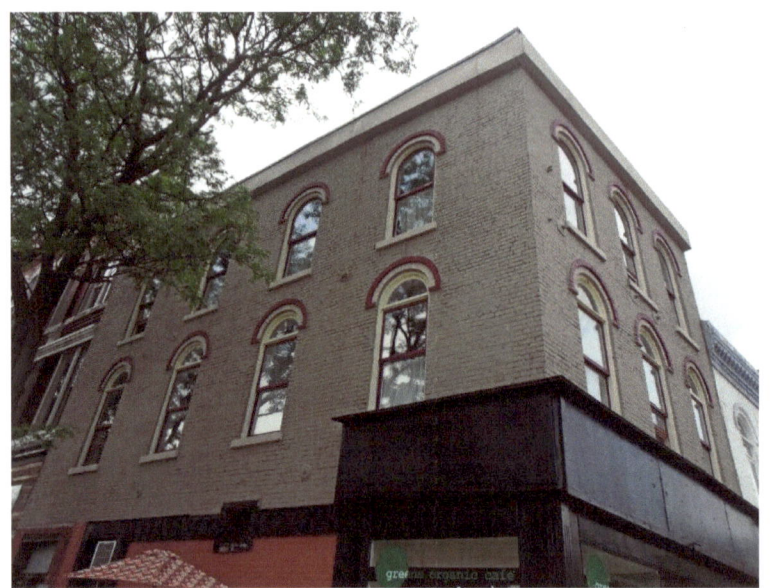

192 Christina Street North – Greens Organic Café - 1890

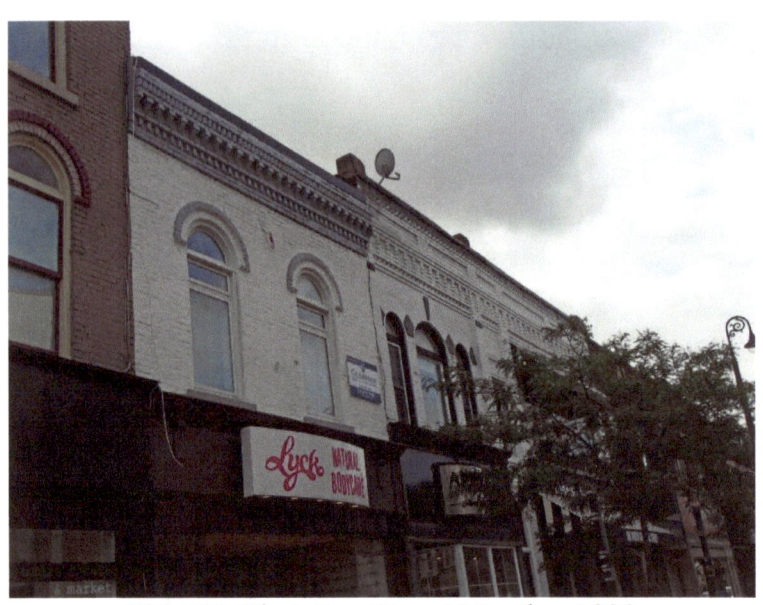

186-190 Christina Street North – 1890
– dentil and saw tooth moulding

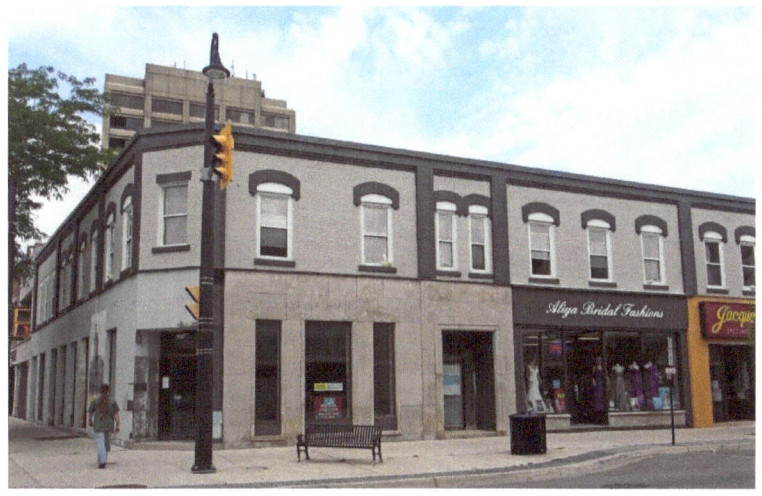

199 Christina Street North – Aliya Bridal Fashions - 1875

 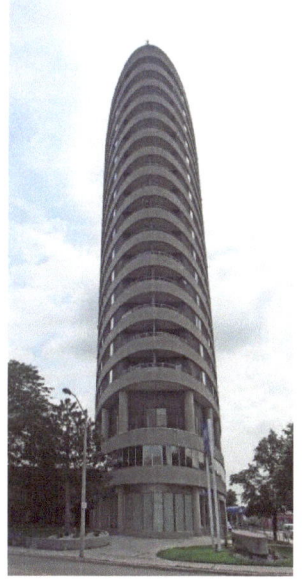

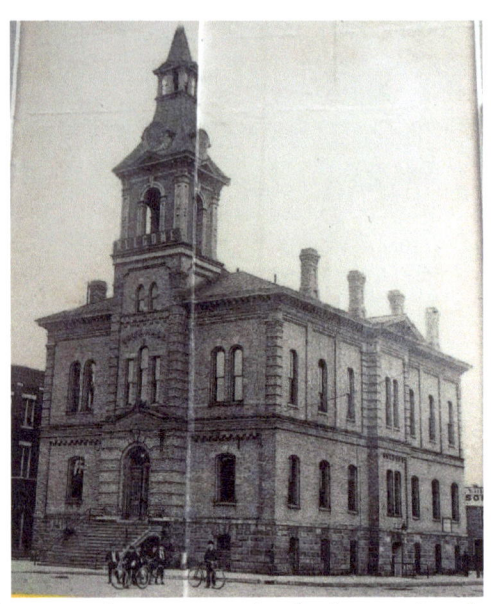

Old City Hall – mural – a stunningly imposing building with a remarkable tower as its centrepiece – built in 1876 – corner of Lochiel and Christina Streets – demolished in 1954

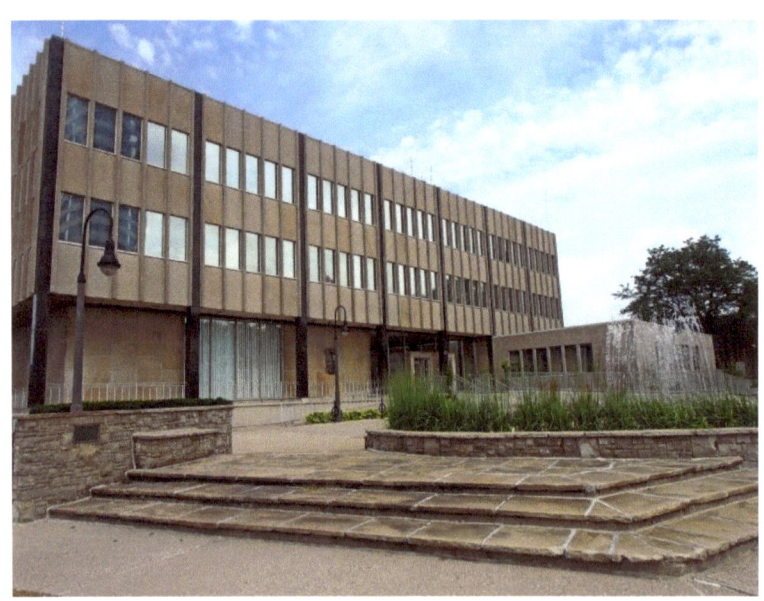

255 Christina Street North – new City Hall

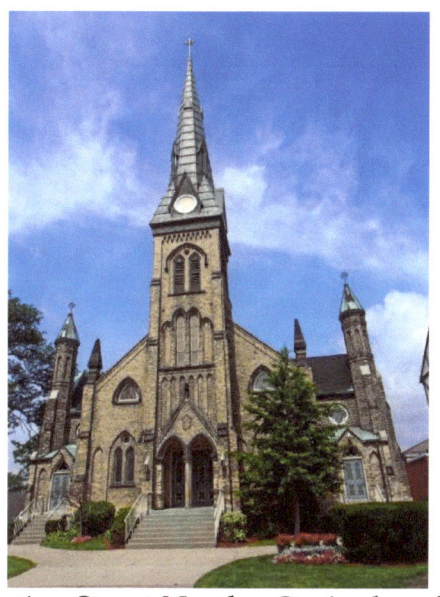

261 Christina Street North – St. Andrew's – 1868

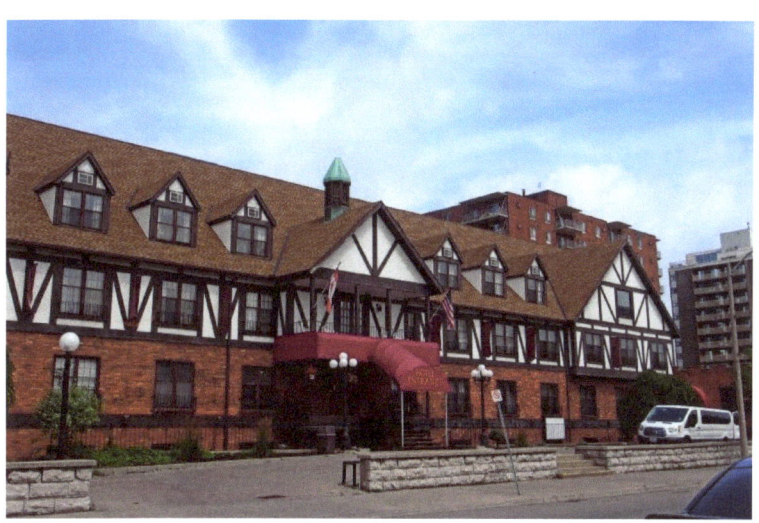

283 Christina Street North – Drawbridge Inn
– Tudor style, dormers

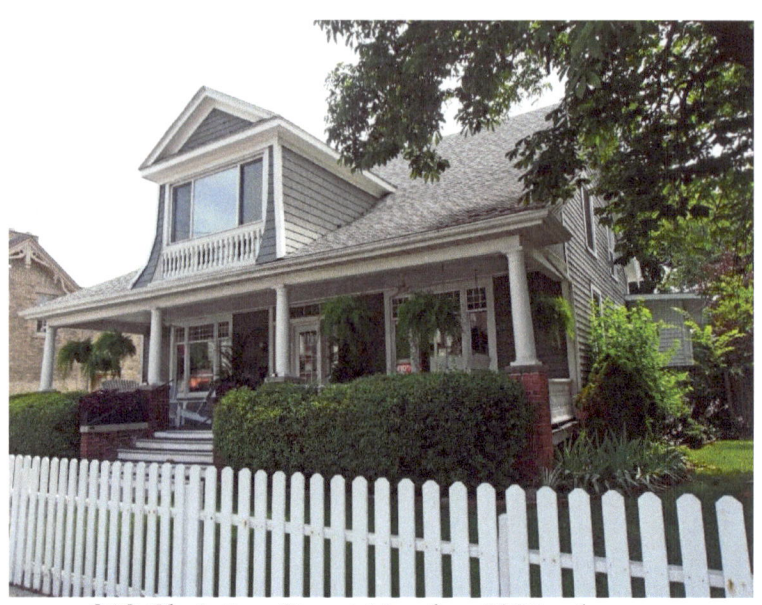

310 Christina Street North – 1890 - dormer

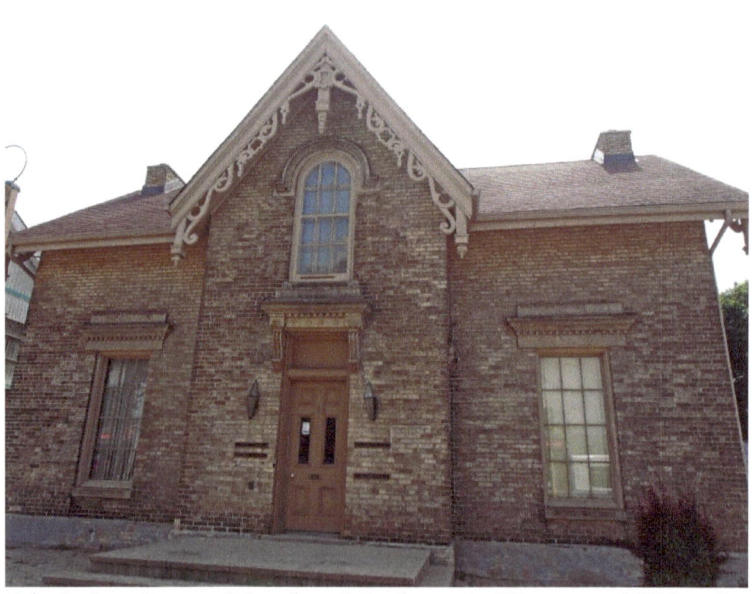

316 Christina Street North – Mackenzie House – 1856 – Gothic Revival – 2-storey brick, high-peaked gable roof, elaborately decorated gable with bargeboard, finial and two pendants

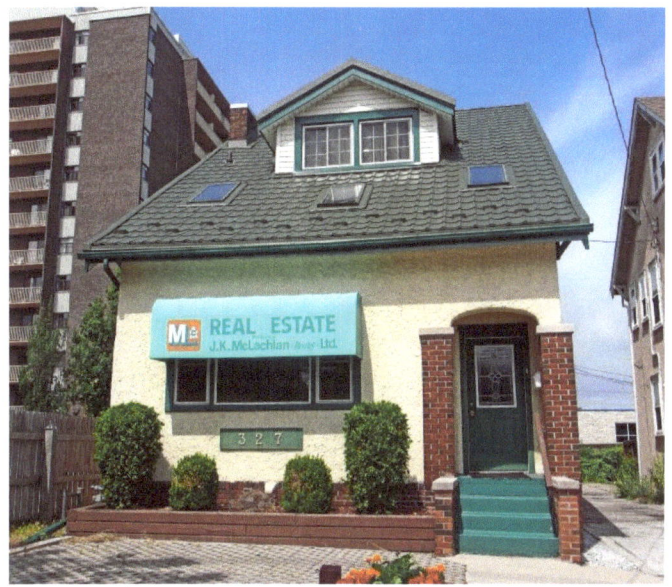

327 Christina Street North – 1925 - dormer

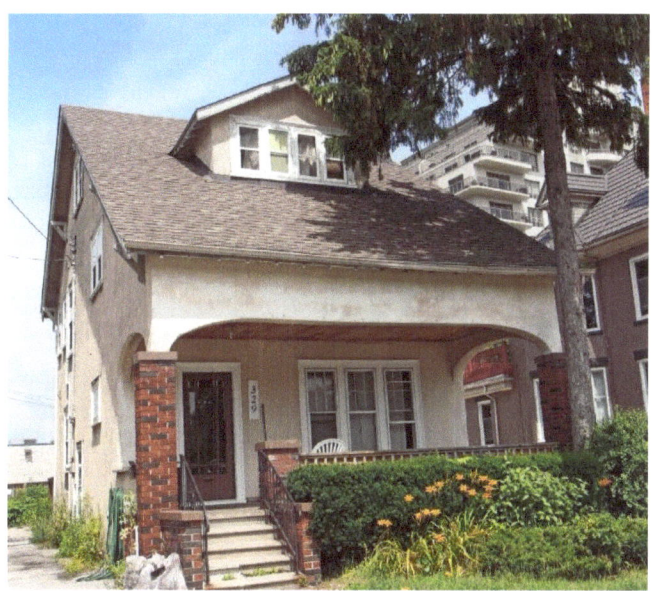

329 Christina Street North – 1934 – dormer in roof

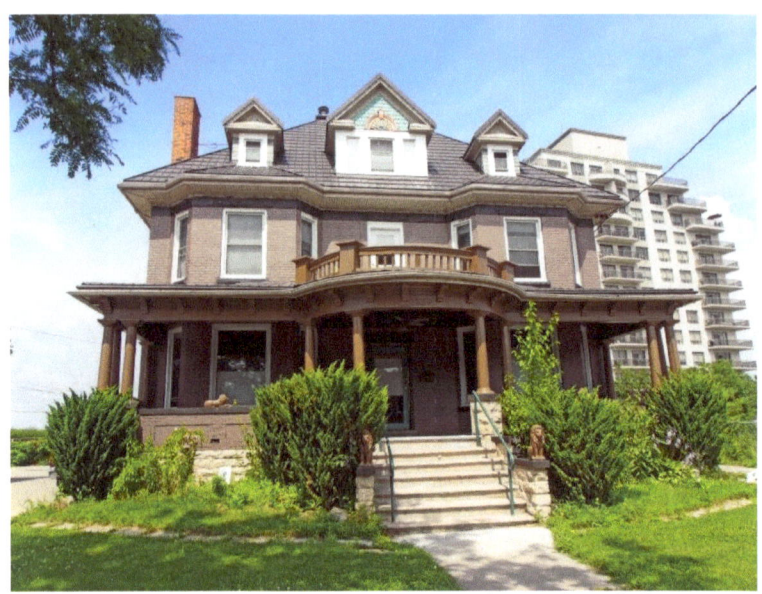

339 Christina Street North – 1907 – Italianate - hipped roof, dormers, centre dormer with cornice return and sunburst decoration with fish scale pattern, semi-circular second-floor balcony, wraparound verandah

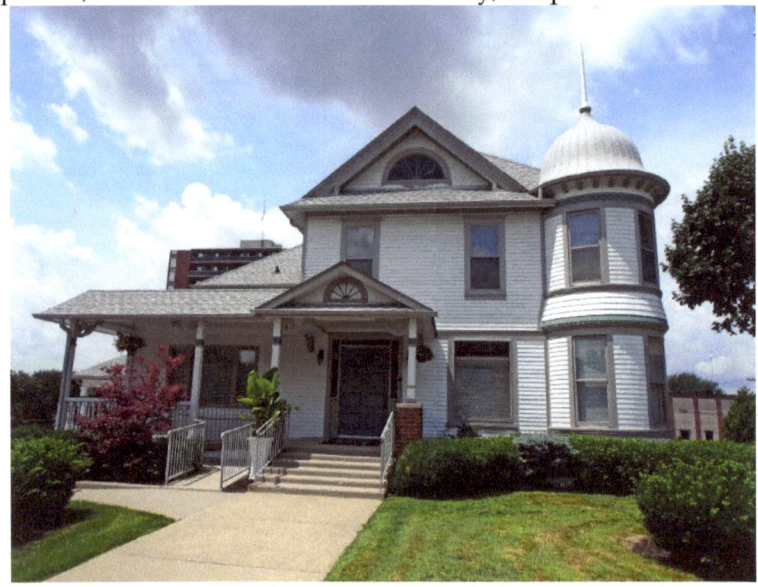

431 Christina Street North – McKenzie and Blundy Funeral Home – a stately residential home built in 1880 – Queen Anne style – turret, pediment

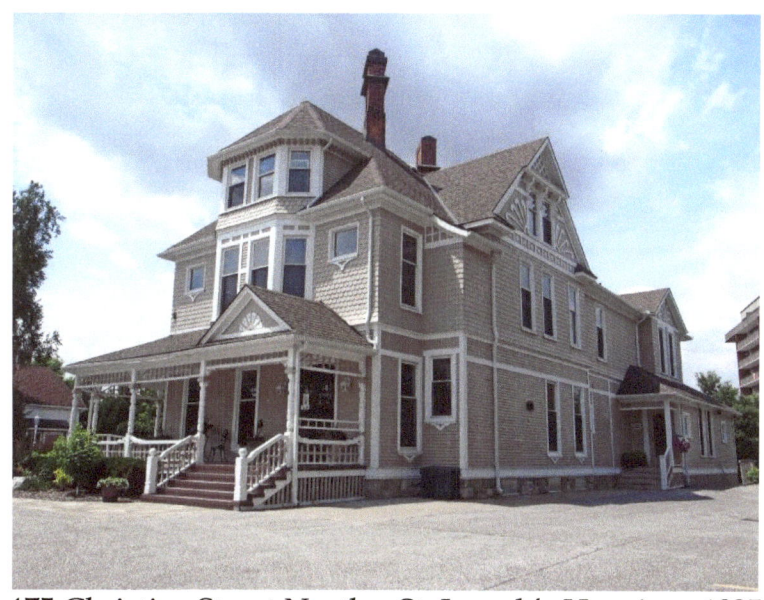

475 Christina Street North – St. Joseph's Hospice - 1825
Fish scale patterning, pediment with decorated tympanum, turret

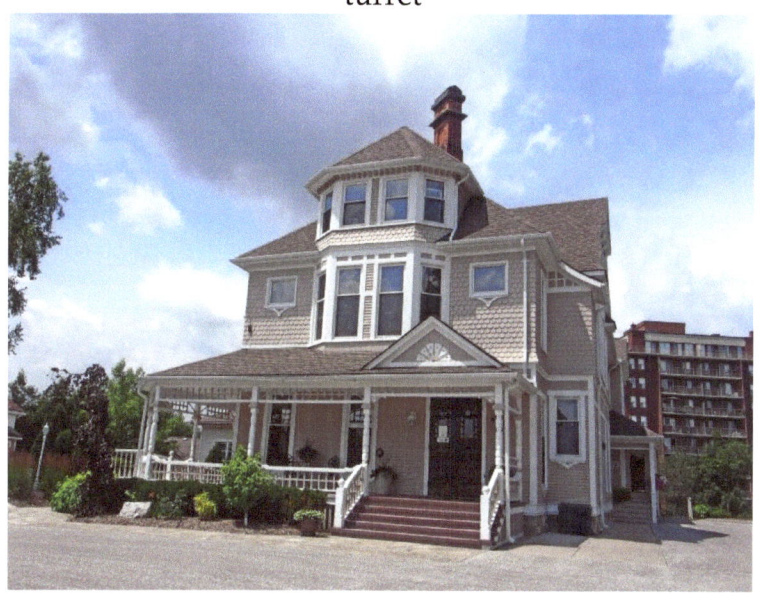

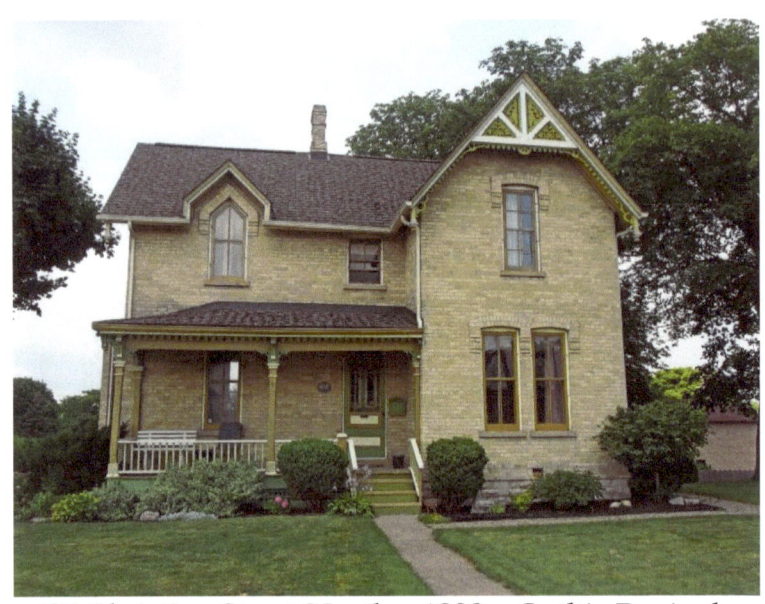

435 Christina Street North – 1890 – Gothic Revival – bargeboard trim on gable with stenciling, arched and rectangular windows with voussoirs

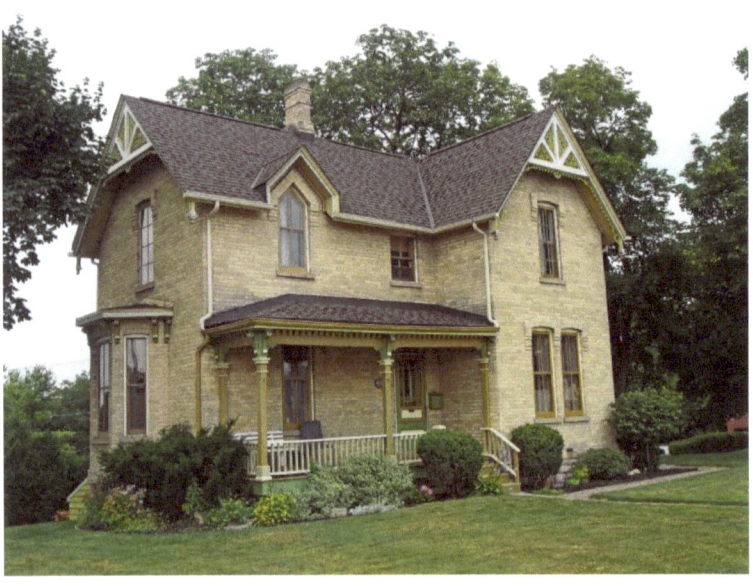

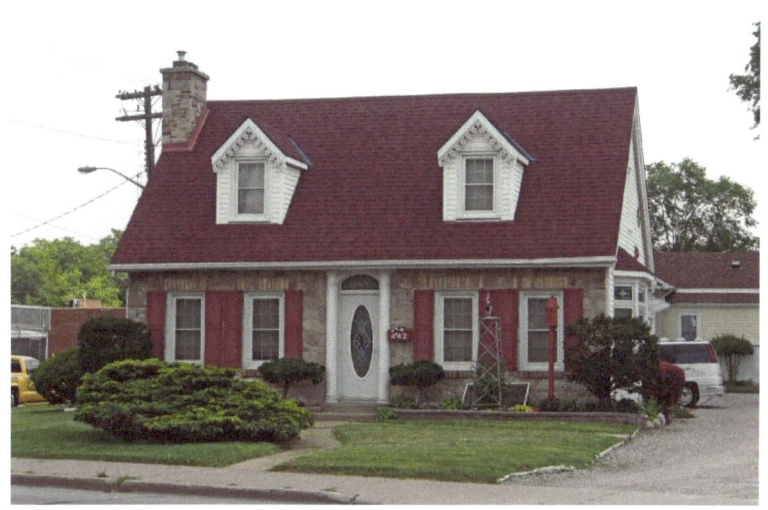

442 Christina Street North – remodelled 1940 – bargeboard on gables of dormers, transom window above door

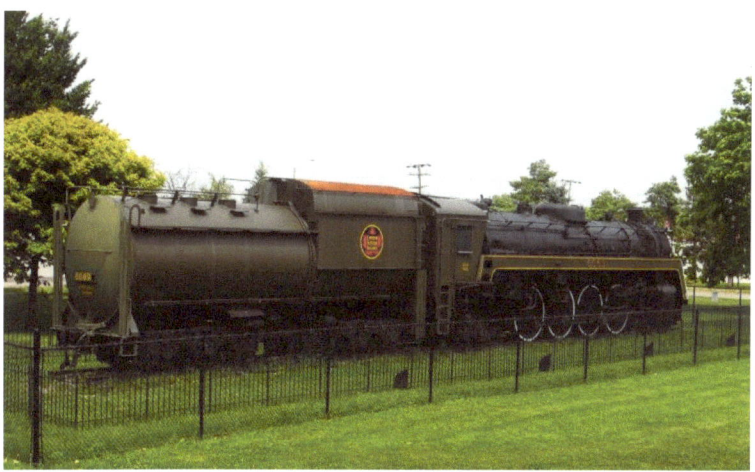

Engine 6069 was one of the last steam engines to be built for the Canadian National Railway. It was built in November 1944 in Montreal – for fast passenger service. The CN's passenger colours were black with green board skirts, cab and tender, white trim and aluminum handrails, gold striping and brass number plates.

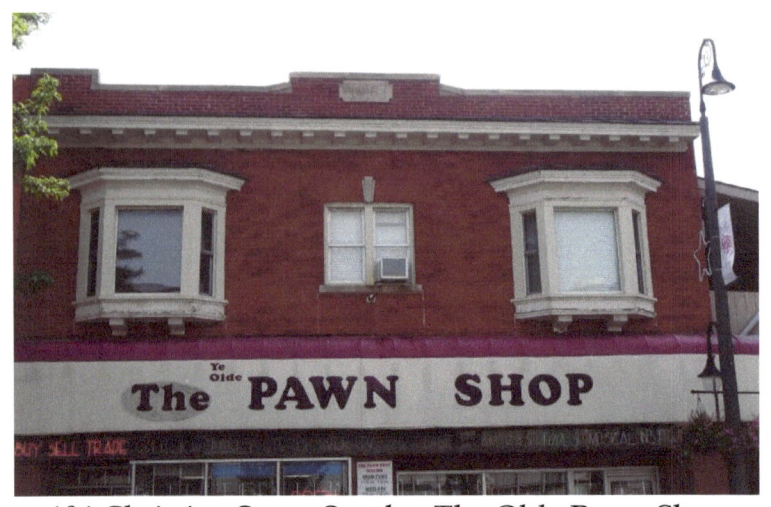

104 Christina Street South – The Olde Pawn Shop
– 1916 dentil moulding, bay windows

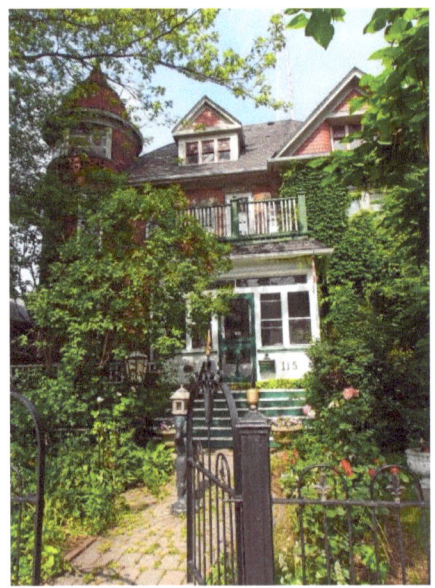

115 Christina Street South – 1890 – 2½ storey double brick
house, large three-storey-high tower with a bell-shaped roof,
on the third storey of the tower is a band shell verandah –
High Victorian style

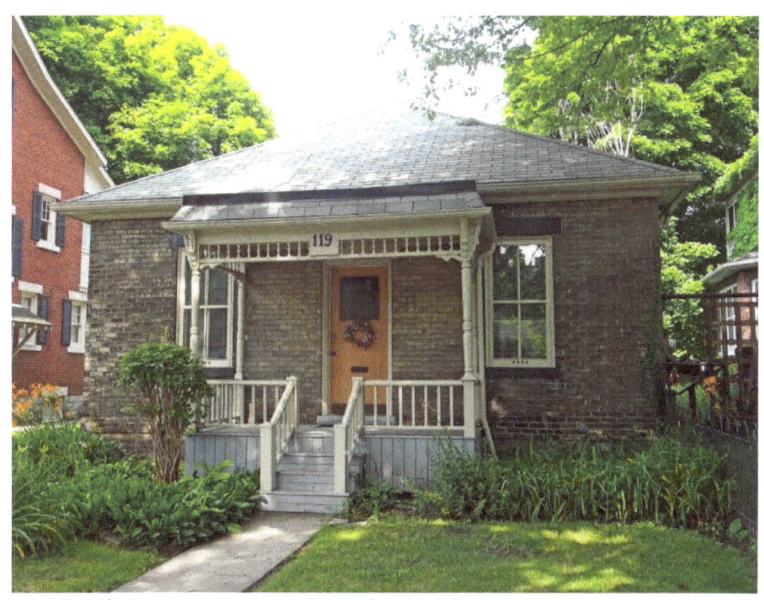

119 Christina Street South – 1901 – Regency Cottage

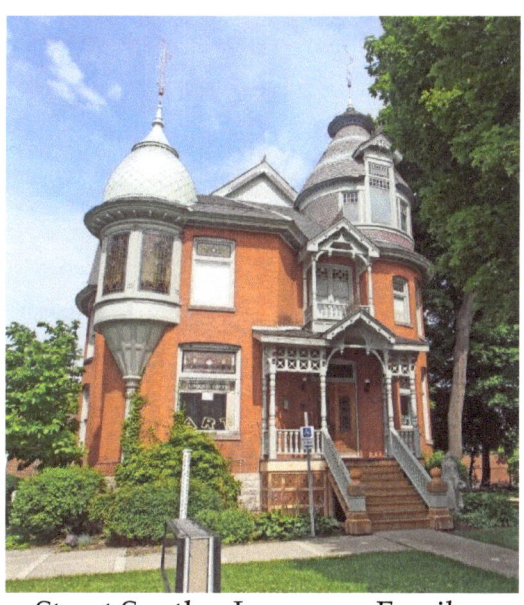

127 Christina Street South – Lawrence Family mansion – Mr. Lawrence was a lumberman – Queen Anne style – 1892

2-storey red brick house, gabled hip roof; the fascia and frieze are a moulded wood and brackets decorate the soffit; circular tower with conical roof peaked with an urn – roofline of tower broken by a decorated gable-roofed dormer; oriel window projects from the left corner of the façade and has a conical roof; vividly coloured stained glass; Eastlake woodwork

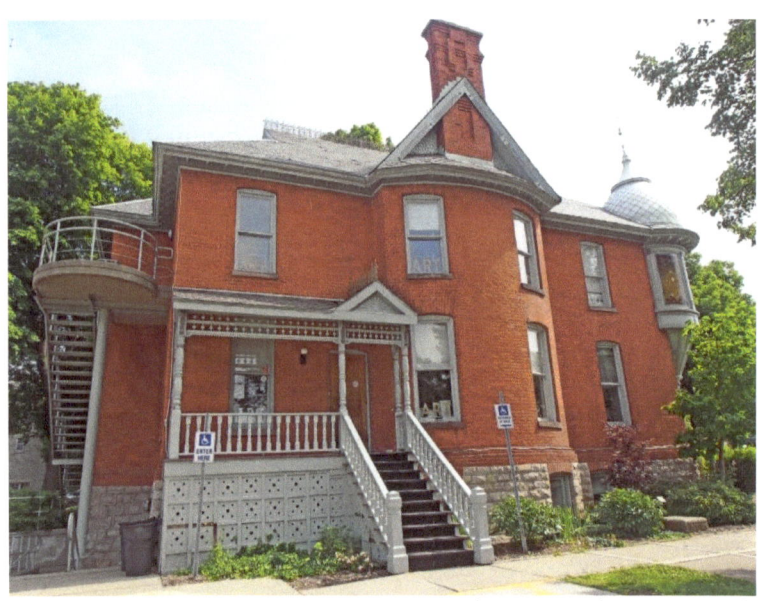

127 Christina Street South - 2-storey bay window extending from south wall with a gable roof

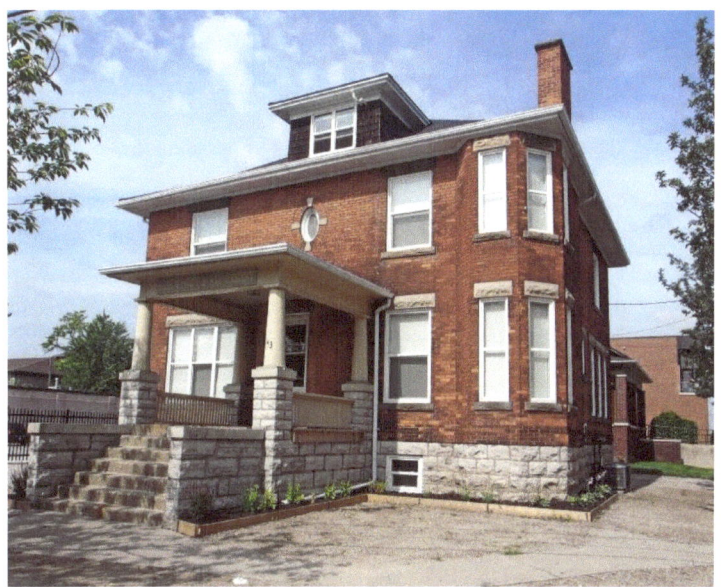

143 Christina Street South – 1900 – Alcove Gift and Art Gallery – hipped roof, dormer

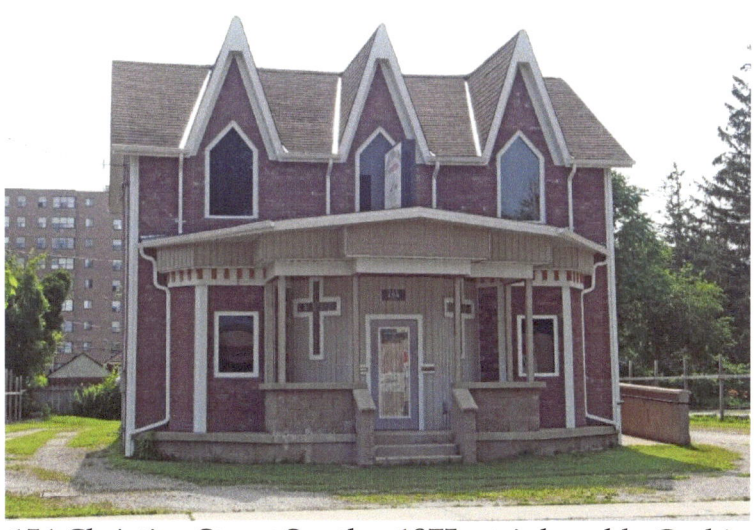

154 Christina Street South – 1875 – triple gable Gothic

160 Christina Street South

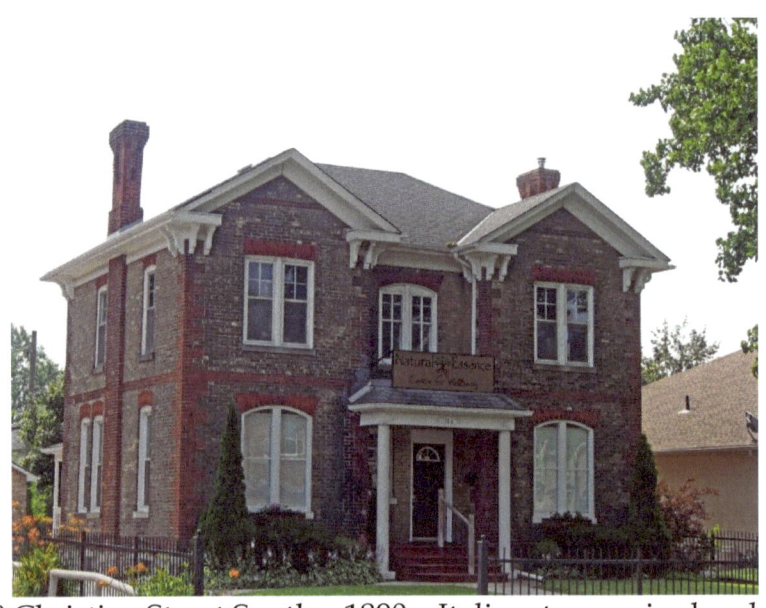

168 Christina Street South – 1890 – Italianate, cornice brackets, dichromatic brickwork, banding

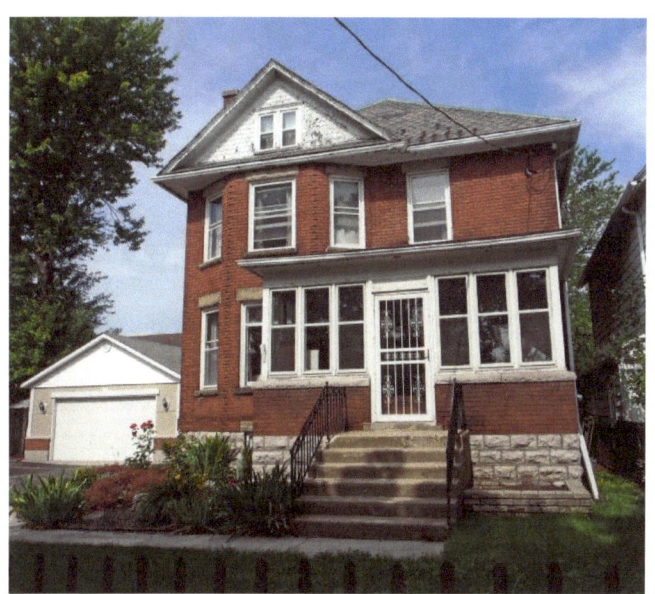

Christina Street South - Edwardian

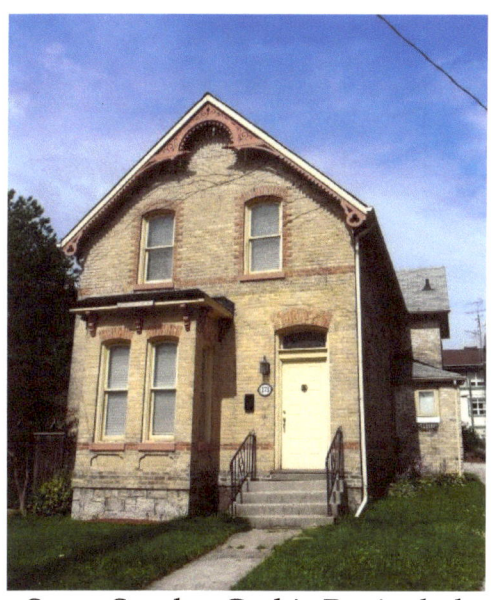

173 Christina Street South – Gothic Revival, decorative arch with stenciling, dichromatic brickwork, banding, rectangular bay window

169 Christina Street South

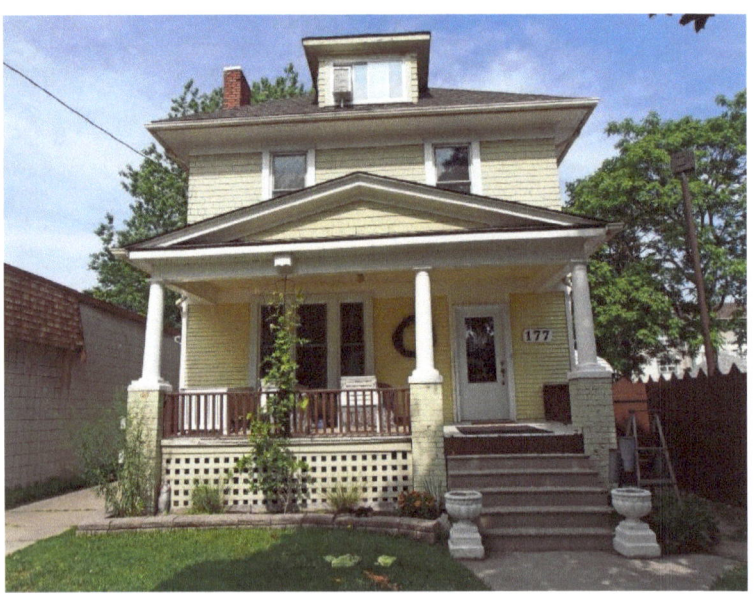

177 Christina Street South – dormer, pediment

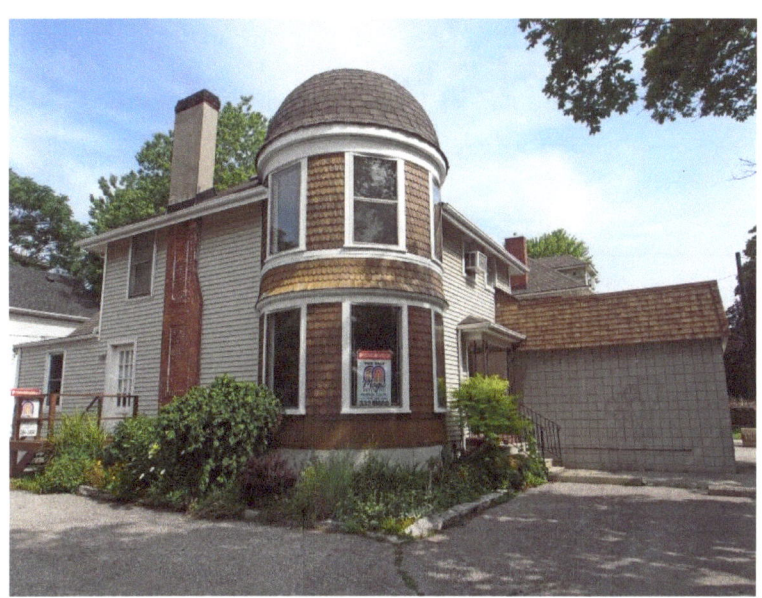

Christina Street South – two-storey turret

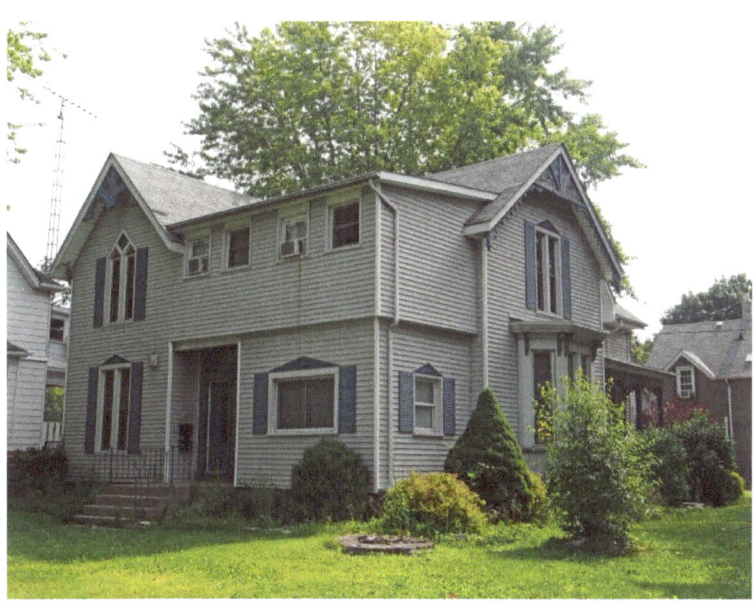

184 Christina Street South – Gothic Revival
– bargeboard trim on gables

Imperial Oil Laboratory

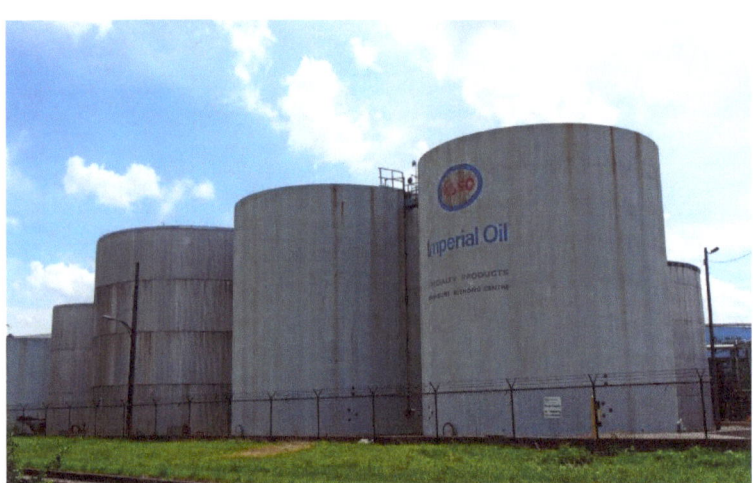

My Dad worked at Imperial Oil building the spheres in 1953-1954.

# Imperial Oil

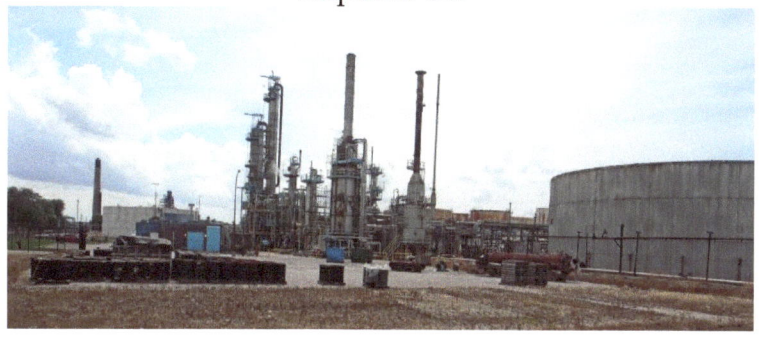

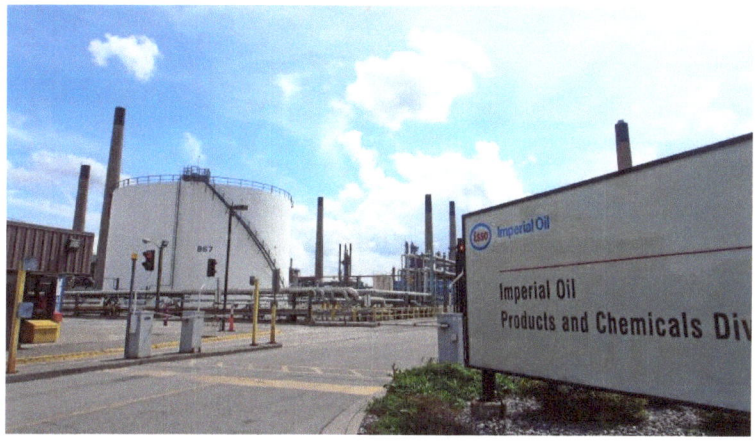

# Architectural Terms

| | |
|---|---|
| **Banding**: Different materials, colours or textures used in horizontal bands along a wall.<br><br>Example: 168 Christina Street South, Page 48 | |
| **Bay Window:** A window that projects out from a wall, in a semicircular, rectangular, or polygonal design. Used frequently in Gothic and Victorian designs.<br><br>Example: 233 Brock Street South, Page 24 | |
| **Brackets**: a decorative or weight-bearing structural element which forms a right angle with one side against a wall and the other under a projecting surface such as an eave or roof.<br><br>Example: 168 Christina Street South, Page 48 | |
| **Buttress**: a masonry structure built against or projecting from a wall which serves to support or reinforce the wall. In Canadian architecture, they are sometimes used for decoration.<br><br>Example: 261 Christina Street North, Page | |

| | |
|---|---|
| **Cornice Return:** decorative element on the end of a gable.<br><br>Example: 315 Brock Street North, Page 11 | |
| **Dentil Moulding**: an even series of rectangles used as ornamental decoration in cornices.<br>Example: 186-190 Christina Street North, Page 34 | |
| **Dichromatic brickwork**: the use of two colours of brick, tile or slate to decorate a façade.<br><br>Example: 168 Christina Street South, Page 48 | |
| **Dormer**: (French for "sleep") a gable end window that pierces through the plane of a sloping roof surface to create usable space in the top floor or attic of a building by adding headroom.<br>Example: 276 Brock Street North, Page 17 | |
| **Fretwork:** interlaced decorative design resembling a bracket<br><br>Example: 275 Brock Street North, Page 17 | |
| **Gable**: the triangular portion of a wall between the edges of a sloping roof.<br>**Jacobean Gable:** the gable extends above the roofline.<br>Example: 129 Alfred Street, Page 6 | |

| | |
|---|---|
| **Iron Cresting**: A decorative ornament along the top of a roof. Iron cresting was popular in the Baroque era and also in Italianate, Victorian, Second Empire and Queen Anne styles of architecture.<br>Example: 127 Christina Street South, Page | |
| **Voussoir**: is a wedge-shaped element used in building an arch.<br><br>Example: 435 Christina Street North, Page 42 | |
| **Oriel Window -** These small areas were originally set into walls and galleries for the purpose of private prayer. Over time, any projecting window or area on an upper floor was called an oriel.<br><br>Example: 127 Christina Street South, Page | |
| **Palladian Window**: a large window that is divided into three sections with the centre section larger than the two side sections and usually arched.<br><br>Example: 233 Brock Street North, Page 22 | |
| **Pediment**: a triangular section above the horizontal structure (entablature), typically supported by columns. The inside of the triangle is called the tympanum.<br>Example: 431 Christina Street North, Page 40 | |

| | |
|---|---|
| **Pilaster**: a slightly projecting column built into or applied to the face of a wall for additional structural support.<br><br>Example: 156 Christina Street North, Page 33 |  |
| **Rose Window:** a circular window with ornamental tracery radiating from the centre.<br><br>Example: 380 Christina Street North | 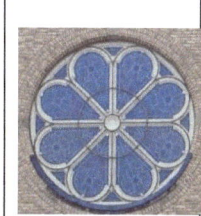 |
| **Sidelight**: a window, usually with a vertical emphasis, that flanks a door, and is often used to emphasize the importance of a primary entrance. **Transom Window:** the light above the doorway, also called a fanlight.<br>Example: 309 Brock Street North, Page 11 |  |
| **Turret:** a small tower that projects from the wall of a building.<br><br>Example: 283 Brock Street North, Page | 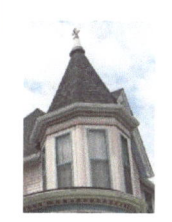 |
| **Vergeboard and Finial**: also called bargeboards – hang from the projecting end of a roof and are often elaborately carved and ornamented. **Finial:** ornament added to the top of a gable, pinnacle, canopy or spire – a Gothic element.<br>Example: 219 Brock Street North, Page 23 |  |

Building Styles

| | |
|---|---|
| Edwardian, 1900-1930 – This style bridges the ornate and elaborate styles of the Victorian era and the simplified styles of the 20th century. Balanced facades, simple roof lines, dormer windows, large front porches, and smooth brick surfaces are its characteristics.<br><br>Example: 213 Brock Street North, Page 23 | 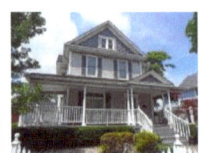 |
| Georgian, before 1860 – This style began with the British King Georges in the 18th century. These buildings have balanced facades around a central door, medium-pitched gable roofs, and small paned windows.<br><br>Example: 270 Brock Street North, Page 19 |  |
| Gothic Revival, 1830-1890 – These decorative buildings have sharply-pitched gables with highly detailed verge boards, pointed-arch window openings, and dichromatic brickwork. It is a common style in Ontario.<br><br>Example: 233 Brock Street South, Page 24 |  |
| Italianate, 1850-1900 – It has wide-bracketed eaves, belvederes, wrap-around verandahs.<br><br>Example: 339 Christina Street North, Page 40 | 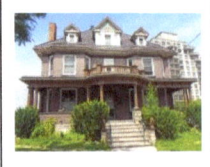 |

| | |
|---|---|
| Queen Anne, 1885-1900 – This style is distinguished by an irregular outline featuring a combination of an offset tower, broad gables, projecting two-storey bays, verandahs, multi-sloped roofs, and tall, decorative chimneys. A mixture of brick and wood is common. Windows often have one large single-paned bottom sash and small panes in the upper sash.<br>Example: 283 Brock Street North, Page | |
| Regency Cottage, 1830-1860 – This style originated in England in 1815 and spread to Ontario later in the 19th century as British officers retired to Canada. It is a modest one-storey house with a low-pitched hip roof and has a symmetrical front façade.<br>Example: 316 Brock Street North, Page 13 | |
| Saltbox: A saltbox is a building with a long, pitched roof that slopes down to the back, generally a wooden frame house. A saltbox has just one storey in the back and two stories in the front. The asymmetry of the unequal sides and the long, low rear roof line are the most distinctive features of a saltbox, which takes its name from its resemblance to a wooden lidded box in which salt was once kept. The earliest saltbox houses were created when a lean-to addition was added onto the rear of the original house extending the roof line sometimes to less than six feet from ground level.<br>Example: 245 Brock Street North, Page | |

| | |
|---|---|
| Tudor Revival – exposed timbers with stucco infill, multi-paned windows.<br><br>Example: 324 Brock Street North, Page | 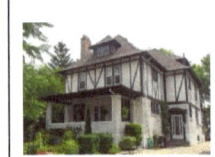 |
| Vernacular/Traditional Mode 1638 - 1950 Influenced but not defined by a particular style, vernacular buildings are made from easily available materials and exhibit local design characteristics.<br><br>Example: 321 Brock Street North, Page 12 | 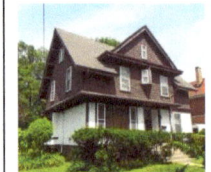 |
| Victorian - In Ontario, a Victorian style building can be seen as any building built between 1840 and 1900 that doesn't fit into any of the other categories. It encompasses a large group of buildings constructed in brick, stone, and timber, using an eclectic mixture of Classical and Gothic motifs.<br><br>Example: 303 Brock Street North, Page 10 | 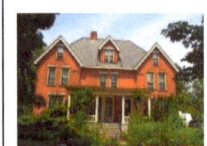 |

www.ingramcontent.com/pod-product-compliance
Lightning Source LLC
Chambersburg PA
CBHW040850180526
45159CB00001B/376